CHARLESTON IS BURNING!

CHARLESTON IS BURNING!

TWO CENTURIES OF FIRE AND FLAMES

DANIEL J. CROOKS JR.

Charleston London

THE
History
PRESS

Published by The History Press
Charleston, SC 29403
www.historypress.net

All images courtesy of the Library of Congress unless otherwise noted.

First published 2009

Manufactured in the United States

ISBN 978.1.59629.635.0

Library of Congress Cataloging-in-Publication Data

Crooks, Daniel J.
Charleston is burning! : two centuries of fire and flames / Daniel J. Crooks Jr.
p. cm.
Includes bibliographical references.
ISBN 978-1-59629-635-0
1. Charleston (S.C.)--History--18th century. 2. Charleston (S.C.)--History--19th century.
3. Fires--South Carolina--Charleston--History--18th century. 4. Fires--South Carolina-
-Charleston--History--19th century. 5. Fire extinction--South Carolina--Charleston--
History--18th century. 6. Fire extinction--South Carolina--Charleston--History--19th
century. 7. Charleston (S.C.). Fire Dept.--History. I. Title.
F279.C457C76 2009
975.7'915--dc22
2009021533

CONTENTS

ACKNOWLEDGEMENTS

Charleston Is Burning! was both a challenge and a delight to write. Of course, an author can do only so much without the help of friends and colleagues.

The work of Nick Butler and his staff in the South Carolina Room at the Charleston County Library must be hailed as nothing short of systematic genius. In particular, Katie Gray went to exceptional lengths to organize and catalogue the volumes of information related to the volunteer fire companies and the early days of the Charleston Fire Department. Their assistance, and kindness, is appreciated.

No research about Charleston can be accomplished without the use of the treasures of the South Carolina Historical Society. Every staff member was gracious and accommodating, never tiring at my seemingly endless list of requests for documents.

A very special thanks to my friends at the Charleston Fire Department. Chief Thomas W. Carr Jr. was recently placed in command of the department and is very excited about learning more about the history of the old volunteer department. Assistant Chief Robbie O'Donald embraced this project from the beginning and greatly contributed to the author's knowledge of "days gone by." Deputy Administrative Chief William F. Finley was quick with the wit and the folklore that distinguishes his agency from others. My meetings and communications with these fine gentlemen were facilitated by Department Secretary Pam Blevins, who pardoned every one of my intrusions for the greater good of telling this story. To every member of the Charleston Fire Department, I commend you and salute you on a job well done!

Most importantly, with every project I undertake, I have my own personal angel, as well as a couple of demons, who humor me through the long hours

of research and writing. Lynn, Daniel and Leah are my greatest supporters, and I thank them for their love and patience.

INTRODUCTION

The history of Charleston in the eighteenth and nineteenth centuries was shaped by fire. Hundreds of infernos resculpted the face of the Holy City, carving out huge chunks of the town and scarring the landscape and its citizens as well. Each new generation learned from the last, keeping a leather bucket full of sand handy should the smell of smoke prompt an alarm.

What folks didn't learn so well was how to prevent the most common types of fires, usually associated with carelessness and neglect. Candles could not burn near drapes without the inevitable happening. Chimneys constantly caught fire because the not-so-privileged burned every kind of wood and scrap available. These materials were more highly combustible than common firewood such as oak. The residue would collect in the chimney, leaving a thick coating that could catch in an instant. The "better" class of citizens was at times equally neglectful, even though small black children were readily available to do the cleaning for a penny.

Known into the early twentieth century as "roo-roos," these barefoot urchins scampered and crawled up and down Charleston's chimneys with trowel in hand, scraping the tarlike coating from the brick. Their songs, chants and rhymes floated up the chimney and out onto the streets of Charleston, the echoes not unlike the sound of pigeons on the roof, hence their nickname.

By the middle of the Civil War, children of means knew that the presence of the roo-roos in December was a reminder that Santa Claus would soon be making his way into their homes with a sack full of goodies. Thanks to the work of those young black artisans, Santa's suit would be clean and soot free. German-American cartoonist Thomas Nast drew the image of a yuletide

spirit both jolly and fat for *Harper's Weekly News*, but children were slow to ponder the miracle of his passage through a chimney much narrower than the jolly old elf's belly.

For two hundred years, the month of December meant that Charleston's less fortunate found their way to an open fire to keep warm. The chill of the winter air pierced the tattered garments of the city's poor as they struggled to keep the fires going. The very wind that brought the cold also spread cinders into the air, and soon a roof or shed caught fire. Another would follow, and soon a conflagration was raging. The flames brought a time of reckoning to everyone. With no consideration for class or status, fires destroyed homes and shanties with equal abandon.

Fire had no favored season, but the warm months precluded the need for the comfort of the home hearth. Behind Charleston's grand homes sat the dependencies, utility buildings that provided what the main house could not. The kitchen house sustained a blazing fire all year long in order to keep the household fed.

The kitchen house was a bustling center of activity, where everything from bread to soup to soap was made. In the heat of a Charleston summer, the temperature inside the kitchen would easily soar above one hundred degrees. Accidents were common as pots were passed from one servant to another. Hands and forearms were burned and scalded. Frocks and aprons caught fire, the flames consuming whole human beings and sometimes the majority of the kitchen house as well.

By the end of the nineteenth century, people were cooking indoors, and "kitchens" were in vogue. Women and little girls gathered around the new stoves that were the centerpieces of the "modern" kitchen, and each generation learned to do what for centuries had been done for them by slaves. Descendants of those servants, together with poor whites, now lived packed together in the abandoned kitchen houses that had been divided into individual tenements. Here the crowded masses continued their careless ways, and fires continued to abound.

In 1882, the volunteer fire companies were combined with the city department to form the Charleston Fire Department. Under Mayor William Courtenay's supervision, the equipment of the old companies was bought up and combined with new city-owned fire engines. The result was a dramatic increase in the quality of firefighting services and a marked decrease in catastrophic fires. The new weaponry of the fire service put an end to the rapid spread of the flames that for years had moved unchecked from one Charleston neighborhood to another.

INTRODUCTION

This book is a history of Charleston's struggle to stay one step ahead of the flames. In the first two centuries of our city's existence, flames lit the night. They illuminated the interior of homes and businesses and guided sailors to shore. It is an evolutionary story, from changes in the lifestyles of Charleston's residents to the advent of the steam pumper. The concern for survival during Charleston's early years remains a viable concern today: the pride of our city's past prompts us into quick action to preserve that very past for future generations.

CHARLES TOWNE'S FIRST FIRE

The historian George C. Rogers observed that "it was the violence of eighteenth century life that kept Charleston society fluid. Disease, fires, hurricanes and wars kept the people from settling down in a long-term routine. Life was short and mortality high. A large progeny was the best insurance for the continuation of the family line."

Known in 1670 as Charles Towne in honor of King Charles II of England, the earliest Lowcountry settlement was situated about five miles up the Ashley River past a high bank of oyster shells known simply as "oyster point." The need for a deep harbor and a more defensible position caused the town proper to move to that same point about 1680. There, with a peninsula bordered on the other side by the Cooper River, the "city between the rivers" would begin to flourish. Chartered and funded by eight of the king's supporters, Charles Towne was a long-distance experiment aimed at identifying profitable crops and trade opportunities.

Earlier consideration had been given to laying out a plan for the new settlement, with Sir Christopher Wren's model of London used as a reference. Charles Towne's streets were eventually laid out by Governor John Yeamans. Edward Crisp published the results of a survey of Charles Town in 1711 that shows the walled city and its layout. That the earlier work of Wren was consulted constitutes a great irony: Wren's work was a plan to rebuild London in the wake of one of the most catastrophic fires in the city's history. Generations of Charlestonians would come to regret that Wren's work had not served instead as a warning of the perils of urban incineration.

London's Great Fire began on September 2, 1666, on Pudding Lane in a baker's shop. Houses constructed of wood caught quickly, as did outbuildings and stores of hay and firewood. Flames moved to the waterfronts, where the

stored quantities of candles, whiskey and turpentine that awaited shipment gave the fire new life as it headed for London Bridge.

It is generally known that London's "bucket brigades" slopped out as much water as they threw passing buckets from the river to the fire. A shorter path, from a nearby well, would have gotten more water on the blaze in much less time. Portions of the city not near the river could have been defended with water from a reservoir, perhaps one formed from a tidal drain. With no other choice, London was blown up in various locations to create "fire breaks," whereby the inferno's progress was arrested by the sheer lack of anything to burn.

Having learned nothing at all from the London disaster, the early builders of Charles Towne set out to build homes of wooden walls and cedar shingled roofs. Tragedy was not long coming.

On February 21, 1698, a fire raged through Charles Towne, destroying at least fifty structures. Just weeks earlier, an earthquake had rumbled underground, leaving the residents standing in the street bewildered. News did not travel fast in the late seventeenth century, so Charles Towne could not have known that only a month earlier, on January 4, London's Palace at Whitehall had been consumed by fire. Whitehall, with its hundreds of rooms, had served as home to the English monarchy since the 1500s.

The February fire blackened about one-third of the town, doing enough damage to warrant the need for some type of fire watch, as well as changes in building standards. A neglectful night watch was encouraged to do better in looking out for smoke and flame, while those in the building trades were asked to build brick chimneys that would be less combustible. Early records from the proprietary period indicate that a tax was levied on those living in Charles Towne, with the funds used to buy firefighting equipment such as ladders and buckets.

It seemed to be the very nature of these early colonists to ignore omens suggestive of doom as long as that doom was not right at hand. Buckets were made available, but not everyone got one. Some on the night watch continued their drowsy routines, while artisans continued to build wooden houses over the charred remains of structures that were just as vulnerable.

As early as 1704, the people of Charles Town began to elect a board of fire masters, which had the authority to supervise any firefighting efforts. These same men were also charged with enforcement of local building codes aimed at preventing the spread of flames. A later law stipulated that all new buildings should be constructed of brick or stone, but the law was later repealed. Increased construction costs and periods of calm caused the town to become disinterested in fire prevention.

Two Centuries of Fire and Flames

Protection for Charles Town from outside forces far outweighed concerns for fire. With bastions at each corner, a wall soon surrounded the town, including a drawbridge near what is now the intersection of Broad and Meeting Streets. Though the town would grow beyond the fortifications in less than twenty years, no amount of water on either side of the peninsula could protect its citizens from their own neglectful ways. Fires would soon become a way of life.

Mindful of the human condition, the Massachusetts Charitable Fire Society published "Directions for preventing calamities by fire." Heeded to the letter, each platitude greatly decreased the danger of fire:

—*Never remove hot ashes in a wooden vessel of any kind and look well to your ash hole.*

—*Oblige all your servants to go to bed before you, every night, and inspect all your fire places before you retire to rest. For fear of accidents, let a bucket of water be left in your kitchen every night.*

—*Do not permit a servant to carry a candle to his bedroom, if he sleeps in an unplastered garret.*

—*If sickness or any other cause should oblige you to leave a candle burning all night, place it in such a situation as to be out of the way of rats.*

—*Never read in bed by candlelight, especially if your bed be surrounded by curtain.*

THE FIRE OF 1740

With the population still fearing the Spanish, the Yemassee Indian War (1715–17) only increased the worries of early Charlestonians. The failure of the Lord Proprietors to protect the colony, coupled with their veto of local laws deemed important to the future of Charles Town, led the townspeople to assemble in protest. In 1721, General Sir Francis Nicholson arrived, acknowledging the land's change of status to that of a royal colony. Wharves along the Cooper River were soon overwhelmed with both imports and exports; naval stores of tar and turpentine were shipped out and gallons of rum were offloaded for consumption in the town's taverns and residences.

The slave population multiplied, as did the number of poor whites. Sturdy, attractive houses stood in tribute to the wealth of planters and merchants alike, while the narrow alleys held hundreds of the less fortunate. Diseases like yellow fever and smallpox were indiscriminate; they killed young and old, the wealthy and the destitute. Fire, that feared predator of 1698, was equally less concerned with one's status. Instead, it longed for a drunkeness conjured up by hundreds of barrels of distilled spirits. On November 18, 1740, a fire became insatiable as it devoured every drop of turpentine, tar and rum stored along the waterfront. Spitting streams of smoke and ash, it roared across the city.

The *South Carolina Gazette* summarized the conflagration for its readers:

> *On Tuesday a fire broke out in this town at two o'clock in the afternoon, which consumed the houses from Broad and Church Street, down Granville Bastion, which was the most valuable part of the Town on account of the buildings and trade; it burnt all the wharves, storehouses, and produce, notwithstanding the utmost care and diligence of the inhabitants of all*

ranks, who were very active in their endeavors to extinguish it. The fire likewise consumed all the houses on the West side of Church Street, from Broad Street opposite to Colonel Brewton which was saved with the greatest diligence, by blowing up several houses, which put a stop to the fire about eight o'clock at night.

The wind blowing pretty fresh at Northwest carried the flakes of fire so far, and by that means set houses on fire at such a distance, that is was not possible to prevent the spreading of it. On this unfortunate occurrence, the assistance given by the Commanders of His Majesty's ships was very considerable, in pulling down and blowing up houses, and particularly by extinguishing the fire in Granville Bastion…The militia was ordered under arms, and proper guards placed in several parts of the Town to prevent the embezzling of any of the sufferer's goods…there was a detachment from each of His Majesty's ships Phoenix, Tarter and Spence on shore, and a party of twenty troopers patrolled up to the Quarter House and around the Town.

Like other fires, the latest one started after an accident in a hatter's shop near the intersection of Broad and Church Streets. Other accounts claim that the fire began in a saddler's house. The quick actions of the citizens and the British sailors prevented the complete destruction of Charles Town. Had the fire not come at a high tide, the loss along the waterfront would have been worse. Ships that escaped on the high water would have burned with the docks had the tide been out.

A letter to Captain Andrew Pringle of London, dated November 22, 1740, from an unknown Charles Town writer, summarized the dockside destruction:

I am now with the utmost grief and anguish of mind to advise you of the most melancholy and fatal calamity that has befallen this town of Charlestown on Tuesday the 18th inst. By fire, which broke out about two o' clock afternoon by accident and the wind blowing fresh at North West, it spread itself with that astonishing violence and fierceness that in four hours time it consumed about three hundred dwelling houses besides a great many stores, some of the wharf and an immense quantity of goods and merchandise and if it had not happened to be flowing water most of the shipping in the Harbour had been likewise destroyed…it is inexpressible to relate to you the dismal scene which much surpasses anything I ever saw of that nature, and is a vast loss and calamity to this Province, the best part of the town being laid in ashes.

Two Centuries of Fire and Flames

To aid in an expedient recovery, an appeal was launched to all citizens of South Carolina. The clergy of St. Philip's Church (spelled variously in periodicals of the time) was charged with the duty of identifying and tending to those persons in the worst need. The people of Charles Town then appealed to the Crown for relief.

It was August 1741 before the Crown agreed that a total of £20,000 sterling would be given to those most affected by the fire. A committee interviewed relief applicants from December 1741 until January 1742. Surviving records from Britain's Public Report Office list every recipient of the king's favor, with wide-ranging differences in the amounts paid. George Seaman received the sum of £5,330 sterling, while John Mountcriff was doled out the small sum of £5 sterling.

An overview of the distribution of the relief funds suggests that the majority of the money went to the city's wealthiest and most prominent citizens. The royal grant was the first and only kind of relief paid to any of the colonies. Having suffered through the Indian War with a populace ravaged by disease, the Crown's intent was to prop up a vital port that had fallen on hard times well beyond the immediate disaster.

In the wake of the 1740 fire, a redundant effort was made to build better chimneys and construct whole houses out of fireproof material like stone or brick. Trades like candle making and liquor distilling were displaced to less populated parts of Charles Town, but only the more legitimate businesses obeyed the order. There had always been clandestine operations in which such goods were produced in order to avoid certain fees and taxes. These volatile components remained mixed in the cramped alleys and yards of tinderbox tenements, ensuring that the latest inferno would not be the last.

Sadly, the arrival of so many slaves had raised suspicions of arson in a population of whites now intimidated by the African race. In September 1739, the Stono Rebellion south of Charles Town saw the murder of several whites and the destruction of their stores and houses by slaves under their charges. Although a number of the insurrectionists were captured and killed, others escaped. The fear of these arsonists and murderers lurking outside the town's limits generated a paranoia that was passed to generations of white children in the form of bedtime stories. Hatred and fear replaced reason, and for so many, it was easier to condemn slaves than to hold oneself responsible for carelessness with both candle and match.

As preachers railed against the "black devils," the people of Charles Town threw a vindictive glance at their shackled servants. On August 15, 1741, a black slave was burned alive for making threats against whites.

From 1735 until 1741, the *South Carolina Gazette* featured several announcements on behalf of the Friendly Society, America's first fire insurance company. The mission of the society was as follows:

> *We do covenant, promise, conclude and agree that we will become humble Suitors to his Honour the Lieut. Governor, and the General Assembly to…enable us to purchase Lands, Houses and Tenements, Goods and Chattels and to lend out Moneys in order to have and establish a Fund, always ready to make good any Loss or Demand that may be made on the said Society…that within 3 days after any Fire and Loss to any person insured, the proper Officers of the society shall survey the Damage, and report the same to the directors, who shall thereupon take such Measures as shall be necessary for the Payment of the Loss sustained.*

Ironically, the great fire appears to have ruined the Friendly Society, whose last published notice was written by one of its directors, Charles Pinckney. The notice is dated February 19, 1741:

> *These are to give notice to the Several Persons indebted to the said society, that unless they discharge their respective Debts on or before the 25th Day of March next, they must expect to have their Bonds put in Suit; and as the Necessity the Society are under for calling in their Money, must be apparent to everyone, it is hoped that no Person will fail of punctually paying of their Bonds within the Time above limited, or take it amiss if they do, if they are then sued without further notice.*

THE FIRE OF 1778

In the last quarter of the eighteenth century, Charles Town was a growing hub of business, sophistication and slave trade, tempered by soaring inflation. Throughout the American colonies, a war for independence was being fought. To finance the effort, paper money circulated at highly inflated rates. Businessmen and planters alike complained of the general decline in commerce. Meanwhile, in what constituted a great political irony, the colonists continued their fight to throw off the manacles that England and its king had placed on their freedoms, unmoved by the daily barter of black men, women and small children no less bound.

Having now moved beyond the confines of the "Old Walled City," residents' early fears of the unknown were replaced with a very specific, and much dreaded, concern: slave insurrection. Thousands of blacks, in the town and the country, were regarded by the wealthy class as potential rebels. The city's elites believed that, with torch in hand, slaves stood ready to lay waste to Charles Town and its people. Even the back-alley white traders of soaps and candles were treated with a wary eye lest the misery of their own lives cause them to fall into union with slaves or British spies.

Each evening a guard was stationed in the steeple of St. Michael's Church at the corner of Broad and Meeting Streets. From this perch he monitored the skyline for smoke or flames. The night watch patrolled the mazes of shacks in which those less fortunate resided, amongst the filth of household refuse, clay chimneys and wooden roofs. Severe penalties were approved for anyone who violated official directives aimed at preventing fires. White men were fined, slaves were whipped and anyone stealing goods from a burning house was locked in the public stocks and bombarded with rotten vegetables.

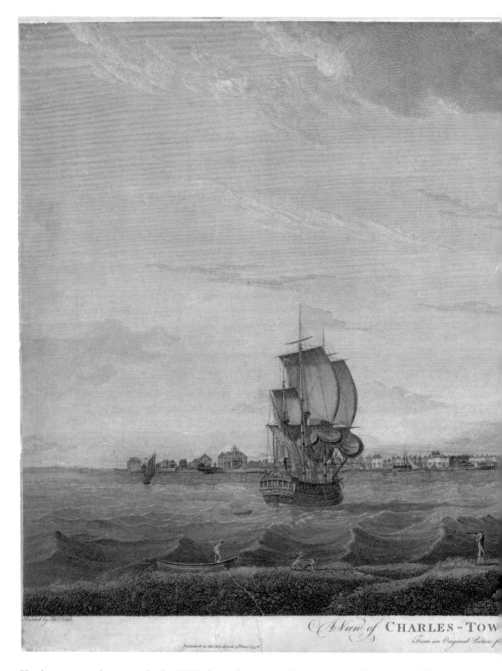

Charleston was a busy port in the 1700s, but urban expansion was stymied by repeated fires that blackened whole blocks at a time. *Library of Congress.*

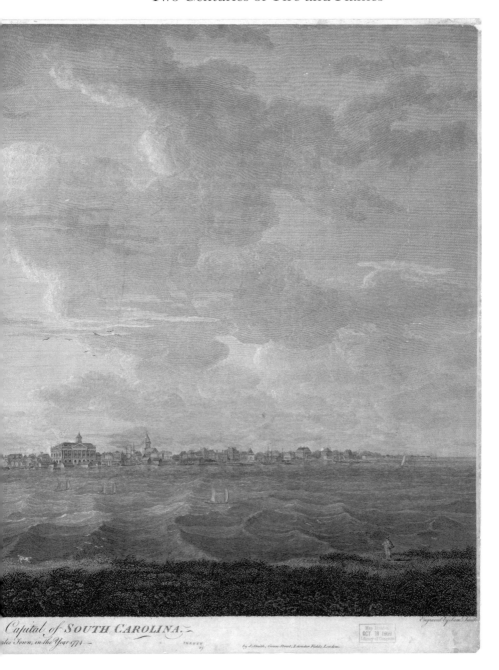

Capital of SOUTH CAROLINA.
...les Town, in the Year 1774. —

CHARLESTON IS BURNING!

Unlike intentional acts, calamities of an accidental nature had no deterrent. In the close confines of a shanty, the dreaded flaming menace could pass as mere candlelight in the dark, only to rise into a tornado of destruction as one innocent soul stumbled while reaching under the bed for the chamber pot.

About four o'clock in the morning on January 15, 1778, a single flame burst forth, melting the icy air and spawning a storm of destruction never before seen by residents of the port city. The actual origin of the fire was described very specifically in a letter from Gabriel Manigault to his grandson, Gabriel, who was away at school in Europe at the time. The letter is dated from Charles Town on February 24, 1778:

> On the 15*th* January about two hours before day broke out a most dreadful fire. It began at a Baker's House on the South Side of Queen Street, the back of Hopkins Price's brick corner House on the Bay, opposite to Mr. Prioleau's wharf, always used for a Tavern.

The *South Carolina and American General Gazette* was specific in identifying the bounds of the ruins:

> The fire was so rapid in its progress that before twelve o'clock it had entirely destroyed all Union Street; the South side of Queen Street, from Mrs. Doyley's house to the Bay; greatest part of Chalmers Alley; all the Bay, excepting fifteen houses from Queen Street to Granville's Bastion; The North side of Broad Street, from Mrs. Thomas Smith's house to the Bay; the South side of the same, from Mrs Sauvegen's to Mr. Guerard's; all Gadsden's Alley; Elliott Street, excepting two houses; Bedon's Alley; the East side of Church Street, from Broad Street to Stoll's Alley, excepting five tenements, and the whole of Tradd Street to the Eastward of Church Street.
>
> The crackling of the flames; the dreadful columns of smoke bearing with them myriads of fiery flakes, which fell in all parts of the Town lying in the direction of the wind; the roar of explosives; the crash of falling houses; the shrieks of the unhappy sufferers; the horror painted in every countenance; the confusion apparent everywhere, and detecting the infamous wretches (and they were not a few) who availed themselves of the opportunity to pilfer, altogether formed one of the most dismal scenes of woe and distress that can possibly be conceived. Much praise is due to the officers and soldiers quartered in the Town, who afforded every assistance in their power to the inhabitants…The number of dwelling

houses destroyed, exclusive of stores and outhouses, is upwards of two hundred and fifty…The whole loss, by the most moderate computation, exceeds three millions of dollars…the number of lives lost is not great. We have not heard of more than six, some of whom are negroes. The Charlestown Library Society's valuable collection of books, instruments, and apparatus for astronomical and philosophical observations and experiments etc. being unfortunately placed in a house in the neighborhood of that in which the fire broke out, is almost entirely lost.

Public notice was given on the evening of the 15th to all those that were at a loss for lodging and victuals, that both were provided for them at the public expense in the several public buildings; and on the 16th, the General Assembly voted £20,000 for the immediate relief of the sufferers. The State of Georgia was not unmindful of suffering Charlestown. Their assembly generously voted $10,000 to relieve the distressed.

In a letter from John Lewis Gervais, a Huguenot emigrant, to his friend Henry Laurens, he described the town's people and their disposition. The letter is dated April 19, 1778:

On my arrival, the sight of devastation affected me, but I did not find the Inhabitants cast down, as I might have supposed it would, and I don't hear of anyone being reduced to poverty by it. The Lots where houses stood sell now for more money [than] *they did before the fire, with the houses on* [them] *and most people saved their goods and effects.*

So much of Charles Town was laid to waste that the ordinary human error of leaving a flame unattended was too simple an explanation for some to accept. Instead, various theories spawned visions of slave incendiaries moving in the night, throwing torches and cursing the fate of the white populace. Others were not satisfied with that theory; they lusted for wartime intrigue, fancying men loyal to the king of England in concert with those same Negroes.

In June 1776, the colonies were in the full throes of revolution. Three British ships had blockaded the Charles Town harbor, intent on disrupting the flow of necessary supplies. By late 1777, an attacking fleet was readied, but the flames of early 1778 did the Crown the favor of leveling the town without any exchange of cannon fire. Instead, talk around the remaining grogshops turned to sympathetic Tories bringing in British sailors in small boats, right under the nose of the watchmen and soldiers along the bay. The surrender and destruction of Charles Town had been put off, but not for long.

CHARLESTON IS BURNING!

By the spring of 1778, Charles Town was busy rebuilding. The legislature passed a new law that provided for the digging of wells, which would provide better sources of water in case of fire. The fire masters were now allowed to inspect buildings for compliance with the new law.

While Charles Town swept away the ashes, the battles of the Revolution wound down in the Northeast. By the middle of 1778, colonial spies informed the citizens of the city that the British would soon bring the war south. In May 1780, the city was encircled by the king's armies, while his fleet stood fast in the harbor; the ensuing bombardment from land and sea brought much destruction and little mercy. May 7 and 8 saw bombs of all sorts hurled into the town, setting numerous fires. The colonial forces dispatched slaves to form the bucket lines as smoke blinded their path and explosions deafened their ears. The year 1778 saw residents of the peninsula city surrender to the wrath of raging lines of fire and destruction. On May 12, 1780, Charles

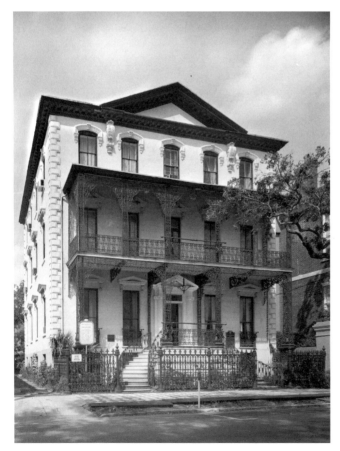

The John Rutledge House stands today at 116 Broad Street in downtown Charleston. Built in 1763, it survived destruction by fire and war. Home to a signer of the U.S. Constitution, the house today is a popular inn, offering travelers a respite from their journey. *Library of Congress.*

Two Centuries of Fire and Flames

Town surrendered again, but this time the exact cause of the most recent fires was not subject to debate: these fires were acts of war.

British general Sir Henry Clinton claimed the city as his prize, while colonial Major General Benjamin Lincoln surrendered his garrison and arms to prevent the complete destruction of a city that had so far escaped oblivion. On May 15, British soldiers were securing the powder magazine off Queen Street when a weapon discharged inside, setting off a thundering explosion. Though the musket fired accidentally, the carnage was devastatingly complete: several houses burned down and many others were adorned by the charred masses of British flesh, which landed on rooftops and in trees.

After an occupation of two years, the British received the order from London to withdraw from Charles Town. A final threat by the British to burn the entire city to the waterline brought about a brokered evacuation. On December 14, 1782, the last of the British occupiers boarded a transport just as triumphant colonials came marching down King Street.

A gentleman named Elkanah Watson was visiting Charles Town at the time of the 1778 fire. In his memoirs, he described the rescue of his most prized possessions, which he had gathered into a trunk. Flinging the case over his shoulder, Watson proceeded to secure the trunk in a residence for safekeeping. The ensuing confrontation with the doorman illustrated just why the folks in town labored under such conditions to retrieve their precious garments:

The fire had extended far and wide, and was bearing down, in awful majesty, a sea of flame…my heart sickened at beholding half dressed matrons, delicate young ladies and children, wandering about unprotected and in despair. I soon found myself prostrated on the ground, alongside of my trunk, by the explosion of a large building. Fortunately, being uninjured, I hastened on until I reached an elegant house in the suburbs of the city. Without hesitation I entered it, and seeing no one, went into a splendid parlor, deposited my trunk in a closet, locked the door, and put the key in my pocket. Early the next morning I went in pursuit

of my trunk. I everywhere saw heart-rending spectacles amid the smoking ruins, and the constant falling of walls and chimneys. I reached the house where I had left my trunk, which I then first discovered was the residence of Governor Rutledge. A young gentleman answered my knock of whom I requested my trunk. He eyed me with attention, and casting a suspicious glance upon my person and clothes, replied, that not knowing me, he could not deliver it. My face and hand had been injured, and my clothes torn in the confusion of the fire. I was mortified, but, conscious that my appearance justified his suspicion, I forthwith proceeded to a friend, borrowed a clean shirt and decent clothes…got shaved and powdered and again proceeded after my trunk. I knocked with confidence, was politely received by the same young gentleman, who evidently did not recall my features. I was ushered into the presence of the Governor. I stated to him where I had placed my trunk, and was apologizing for the liberty when he interrupted me, remarking that the fearful crisis justified me. He continued—"Sit down, sir—will you have a glass of wine? My secretary informed me that a person called for the trunk an hour or two ago, but not liking his appearance he declined delivering it." The Governor was much amused at understanding that I was the person who had called. I record this incident to show the importance of external appearances to a man's success in the world, and more particularly among strangers.

AFTER THE REVOLUTION

O n February 5, 1788, the former statehouse of the royal colony burned down, satisfying some in Charleston (as it was now called after the Revolution) that the last physical remnant of the Crown's power was itself in ashes. The fire caused the ratification convention for the new constitution to be moved to the Exchange Building at Meeting and East Bay Streets. It was there that the convention also voted to move the capital from Charleston to Columbia. In a "Sketch of the History of Charleston," published in the city's 1880 yearbook, the details of the fire at the intersection of Meeting and Broad Streets were described:

> On Tuesday evening, 5th February, a fire was discovered in the Senate Room of the State House, which, in a few hours, reduced that building to a pile of ruins. The conflagration commenced by the intense heat of the fire catching a part of the wainscoating which projected over the bricks above the fireplace. Several persons rushed into the room, and could have easily extinguished the fire if they had been readily supplied with water; but after this necessary repellant arrived in sufficient quantity, the flames ascended into the upper story, and there formed a crown of ruin over the whole building. Happily, for the adjacent houses, there was a very light wind, until nearly the fury of the fire was spent.

For almost one hundred years, fires had continued to eat away at Charleston, block by block. After the 1698 fire, city officials implored the public to keep a simple bucket of water or sand on hand, should a stove or fireplace pose a hazard. One bucket of water could have saved the former statehouse. The burning of that public building marked the first time that a significant Charleston landmark was destroyed by fire.

CHARLESTON IS BURNING!

Just eight years after the statehouse burned down, flames threatened several of Charleston's venerable houses of worship. Fire was proving to be an omnipresent reminder that carelessness was mankind's greatest folly. A dropped candle or a stray cinder in a room off Lodge Alley soon spread flames to neighboring buildings. The *Columbia Herald* of June 16, 1796, carried the news of destruction in the port city, though the origin of the fire differed from the local reports. Citizens of Charleston still feared slave revolts, a hangover from the French Santo Domingo revolution in 1791, described in three terrifying words: murder, blood and flames. Many of that island's people had fled to Charleston for protection and were suspected as the likely culprits:

> *A fire was discovered in Lodge Alley, said to have broke out in a stable loft, which instantly caught the lodge house and from thence soon communicated to the adjacent buildings. A brisk gale blowing from the eastward spread the devastation westwardly, and in spite of the exertions of the citizens, with fire engines etc., the fire spread against the wind to the bay…whoever will take a tour beginning at the N.W. corner of Broad Street and the Bay…will find but a small portion of the houses within the space enclosed remaining. The fire raged more than twelve hours, and many families yet remain unhoused owing to the over population of the city by the immigrants from St. Domingo.*

Charleston's *City Gazette* reported its version of the conflagration. It is said that the hero who saved St. Philip's from certain destruction was named "Boney." According to local legend, he was given his freedom and also a boat:

> *The fire consumed every house in Queen Street, from the Bay to the corner of Church Street; two thirds of Union Street; Church Street from Broad Street to St. Phillip's Church…The public buildings destroyed, were the French Church and the beef market. St. Phillips Church was several times on fire, and must ultimately have been destroyed but for the exertions of a spirited black man, who ascended to the cupola, next to the vane and tore off the shingles. On the following morning, upwards of 500 chimneys were found standing. The distressed situation to which upwards of 200 families are reduced by this disaster, is easier to be conceived than described.*

Such life-threatening benevolence was beyond a slave, according to Charleston historian Walter Rhett. It was more likely that the slave maneuvered his way to the roof, struck a match to a rag soaked in turpentine

and started a small fire himself. Thus "saving" the church, he won his freedom, which was the aim of his scheme all along. Rhett also contends that slaves were constantly inventing ways of "getting over" on the white people who dominated them. This game of cat and mouse continued into the twentieth century until civil rights leveled the playing field.

The theft of goods from a building during or after a fire continued to plague property owners and public officials alike. The *Herald* went on to discuss an incident involving a couple of thieves who proved to be pretty slippery fellows when it came time to arrest them:

> *In consequence of information given before Wm. Cunnington, Esq., one of the justices of the peace…he filed a warrant against John Fail and George Sinclair, for having in their custody a trunk of woolen clothes stolen…during the fire.* They evaded the authorities [and boarded] *the ship* George, *under sail for New York, yesterday morning. Mr. Cunnington procured a boat to pursue them; in the meantime, Mr. Crafts ordered Captain Batty to take them to the exchange: the moment they set foot on shore, they disappeared, and were pursued by a great number of constables without effect—Mr. Archibald Harvey who had been in pursuit, discovered them…retook them and lodged them in the guard house.*
>
> *Mr. Cunnington, finding it necessary to detain them in the guard house, under strong precautions and injunctions not to let them escape, till he had completed his information and made further searches, sent the officers of the peace for them, about 11 o'clock, when they had all escaped: the posse comitatis was immediately raised, when the citizens, highly to their credit, attended the magistrate, and with astonishing perseverance recovered them all and safely lodged them in irons in gaol, to take their trial at the next court of sessions.*

Again, as with Charleston's other disasters, a citizen's committee was formed for public relief. In consequence of the needs of so many and the piteous emotion of those who escaped any loss, the following plea was made in the *Herald*:

> *The committee earnestly requests the inhabitants to call and…give them such information as will enable them to distribute the bounty of the citizens in a manner proportionate to the real circumstances of the sufferers.*

The hundreds of blackened brick chimneys that remained stood as testimony to their immunity from the flames, quiet testimony that no one

heard, as plans were made to rebuild more wooden homes over the very same lots.

The last year of the eighteenth century saw a fire on August 4 that was, if not tragic, almost laughable. The event that started on King Street just three doors above Boundary Street (now Calhoun Street) began when Martin Miller tried to stop a leak in a cask of brandy. Miller examined the puncture while holding a lit candle in the other hand; bringing the flame too close to the alcohol, a fire began. The brandy was apparently stored in the vicinity of some amount of gunpowder, which all went up in an explosion that spared Miller but burned his house and several others to the ground.

Fine clothing, china, silver and good brandy were the signature goods of Charleston's upper classes. Importation took time, so no energy was wasted gathering these commodities from houses threatened by fire. None of Charleston's finest citizens wanted to pass the social season waiting on clothes to arrive from England or France. In some instances, this recovery took precedence until the walls were pulled down to smother the fire. In other instances, fires spread with such abandon that several buildings would simply be blown up to impede the fire's progress.

Those in Charleston who lived the life of the less fortunate had less to lose and less time to get what few things they had. The poor typically lived in such small shanties that a dozen would catch fire at one time, burning everything in a matter of just a few minutes. These victims depended on the charity of Charleston's churches for clothing and sustenance.

This system of social stratification contributed to the difficulty in rousing the interest of the greater public to firefighting. When the fire being fought was one in a larger dwelling, it was likely the home of a person of means who stood to suffer a significant loss. Because the poor stood to gain nothing by saving the grander home, they turned away, involving themselves only during that brief time when their own tenements stood a small chance of survival. Slaves, as the purchased chattel of the household, had an obligation to fight the fire and retrieve as much as possible from the flames. Worn by the years of servitude, not every slave could be expected to give his or her best effort when, again, it was their master who stood to lose.

More dependable at the fire were merchants and tradesmen who would suffer a loss of business from the wealthy if burned out of their means. Both before and after the Revolution, British and then colonial troops assisted in firefighting because they sensed that it was their duty and most importantly because they were likely ordered to do so by their commanding officers. Eventually, there were usually enough people willing to attempt to control the flames.

Two Centuries of Fire and Flames

The common method of fighting a fire at the time was known as the "bucket brigade." Two parallel lines of citizens lined up from the water source to the fire, which in many instances proved to be quite a distance. One line passed up filled buckets of water, while the second line returned empty buckets to the well. Because the success of public firefighting was generally poor, the people of Charleston turned to private volunteer companies for protection. Such organizations were formed in Boston and Philadelphia during the early eighteenth century but gained interest in Charleston only after the Revolution.

By 1778, the board of fire masters had been reorganized in Charleston. New responsibilities included directing efforts at the fire scene, providing for the necessary equipment to fight the fire and ensuring that nearby wells and cisterns held enough water to fight a fire. The masters were also empowered to inspect private property, looking for any set of circumstances that could accidently come together to create a blaze.

These masters were socially prominent and politically appointed. Favoritism and compromise diluted a position intended for the common good.

In 1784, the informality and confusion of the "bucket swingers" were replaced by Charleston's first organized volunteer company, the "Hand in Hand." Members paid dues and were expected to fight any and all fires, with perhaps some expectation that their own homes would receive some added attention. Members practiced and drilled, developing a skill for passing water previously unsurpassed by the work of ordinary men.

Primitive hand-pumped engines originally designed in England were first advertised for sale in Charleston in September 1734. An apparatus of this type was soon in use by the Hand in Hand Company and proved to be more efficient, but no less exhausting, to operate. The engine was basically a tub on wheels, with a pump operated by a long handle on each side. Men took turns pushing the bars up and down as water passed through the attached leather hose. To keep up both their rhythm and spirits, the volunteers would sing a jaunty song, usually about some lovely lady. One veteran recalled the words "Lindy gal, oh Lindy gal" from his youth. This exercise also served to regulate the men's breathing under such duress.

CHAPTER 5

THE EARLY VOLUNTEER FIRE COMPANIES

O ne of the first volunteer companies to actually be incorporated in
Charleston was the Vigilant Fire Company, which was founded in
1789. The company acquired a firehouse, a hand-pump engine, buckets and
hooks. Large bags were acquired to hold salvaged valuables such as china
and silver. The rules of the Vigilant detailed the business of maintaining the
necessary equipment and responding promptly to the alarm:

> The fire masters are to assist the president in making such arrangements of
> this company for the extinguishment of fires, or for the removal of property
> endangered thereby, as they shall deem most proper and judicious. An
> inspector shall also be appointed monthly by the president in rotation among
> the members, whose business shall be to call once on each member, inspect
> his buckets and bags, and report their condition at the next meeting…each
> member at his own expense, shall provide himself with, and keep in good
> order, two leather buckets to contain three gallons each, painted on the outside
> a stone color, with a black label on one side, in which shall be lettered with
> white his name…below it in a semi-circle "Vigilant"; together with two
> strong canvas bags, each one and an half yard in length, and three quarters
> of a yard wide, with a running string at the mouth, marked in the same
> manner as the buckets.
> That each member on the alarm of fire being given, shall immediately
> attend with his buckets and bags for the suppression and extinguishment of
> the same, and act in concert with the other members of the company.

Charleston's Vigilant Fire Company's petition for incorporation to the South
Carolina House of Representatives and the Senate was at first rejected because

it wanted to fight the fires involving its members first and only then would it contribute to the greater general good. By 1794, they resolved to allow their company to be placed under the jurisdiction of city council and its fire masters.

From this time until the eventual formation of a fully funded public department in the late nineteenth century, the various volunteer companies worked in close concert with council; public funds paid for stations and equipment, while the companies supplied the manpower. When membership dues had accrued a substantial balance, volunteer companies sometimes bought additional buckets and hooks. City council was the primary channel of communication between the needs of the public, the wants of the volunteers and the requirements of the masters.

Despite the growth in the number of volunteer organizations, council brought coordination of the firefighting effort to the forefront of its concerns. In 1790, the Phoenix Fire Insurance Company had commissioned a map of Charleston that identified buildings that were susceptible to fires, the location of public wells and the widths of various streets. Once circulated to the public, the map served as a valuable tool for the volunteers.

With the expansion of the fire insurance business in England, many companies formed their own fire departments. These independent units consisted of men and equipment designated first and foremost as responders to properties of their insured clients. Any contribution to the greater firefighting effort was an apparent afterthought. The simple logic followed that these dedicated forces could remove more personal property and more exuberantly put out fires than similar but less inspired public firemen.

The English tradition of placing the identifying mark of the insurance company in a conspicuous location on the building's façade was perpetuated in Charleston, but here it served only as advertising. Some plaques were illustrated with eagles, others with angels. Another popular motif was to show a kind of firefighting apparatus, such as an early hand pumper, or later, the steam engine. Volunteer fire companies competed for a bonus premium paid to the first company on the scene, but none of the insurance companies utilized the services of its own company men. In some cities, the insurance company rewarded the volunteer company first on the scene.

Bonuses in Charleston were paid out of public funds. There is no available evidence that the City of Charleston was then reimbursed by the fire insurance company. (A detailed examination of council minutes, resolutions, newspaper articles and actual firehouse journals fails to identify a single volunteer unit in any way associated with a private insurance company. These journals do provide many examples of premiums paid by the city for the first volunteer fire company to arrive at the scene.)

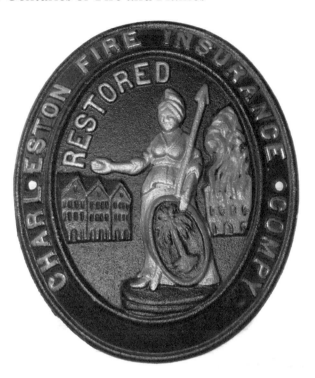

Right: Charleston boasted of two fire insurance companies that did a thriving business because of the number of claims. The Charleston Fire Insurance Company's plaque, or mark, notes that the insured property is "restored." *Author's collection*.

Below: The Mutual Insurance Company mark displays an angel passing over Charleston, pouring water on a fire below. *Douglas Bostick Collection*.

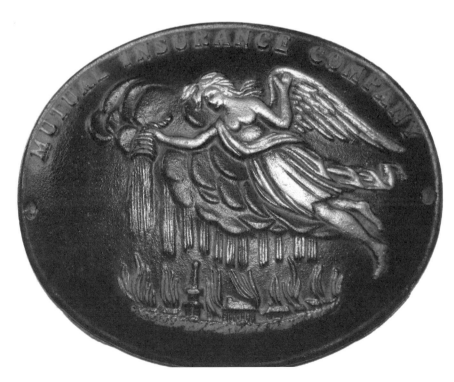

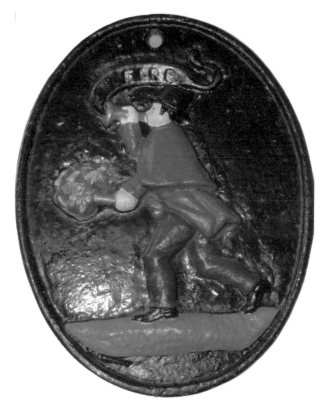

This fire mark illustrates a volunteer fireman from the early nineteenth century alerting the public to a fire. The torch is carried because it is night, and the torch will serve as the rallying point for other responders. The boots, cape and hat are part of a typical fireman's motif from that period. *Author's Collection.*

Despite oral tradition to the contrary, volunteers never stood by to watch a house burn because of who the insurer was or wasn't. The fire mark did put a potential arsonist on alert that the property was fully protected and would be rebuilt. Serving as valuable commercial signs as well, fire marks were replaced on rebuilt homes in proud recognition of having fulfilled the insurer's mission of making the owner whole once again.

In 1801, the Charleston Fire Company of Axemen became the first new volunteer company of the nineteenth century, standing ready with the Vigilant Company to respond to the alarm. Buckets, hooks and hand machines made up the basic firefighting arsenal for the first half of the new century. The advent of steam and its superiority in pumping water onto a fire would not be introduced until Charleston was in the early throes of an emergency unlike any it had faced before—the Civil War.

THE FIRES OF 1810, 1819 AND 1826

The new century came to life against a backdrop of intrigue and activity. Charleston's economy was rebounding, with the demand for Sea Island cotton greater than ever. The export of indigo, on the other hand, had dramatically declined due to competition from British-ruled India.

Religious diversity was the tradition of the day, with a Jewish population that outnumbered any other American city. Relations in Charleston between slave and slave owner were generally peaceful, but the sheer number of Africans, including many free persons of color, constantly played at whites' insecurity due to their numerical inferiority. Fear of revolt like that in the Caribbean during the last century had led to a suspension of human trafficking until 1803, when demands for local commodities overrode any lingering paranoia. Once again the stench of the slave hulks off Charleston's bar drifted across Bay Street and into the business district.

It had been ten years since the smell of smoke sent a wave of panic through Charleston's alleyways. On October 9, 1810, the city was reminded that fire was not a threat of the past—it was a demon that knew no end, waiting for some small failure of human nature to burst forth. This time the flames began in a small house on Church Street, between St. Philip's Church and Anson Street. The *Charleston Times* newspaper heralded it as a "Dreadful Conflagration":

> *At half past 11 o'clock a fire broke out in a small wooden house...as the whole of this part of the city consisted of wooden buildings, the flames soon spread to the adjoining houses and raged with uncontrollable fury. No rain having fallen since the 12th of last month, the houses caught like tinder. The fire spread along Church Street to Amen Street, and down this street*

to Motte Street…consuming all the houses on each side, except one, down Queen Street, through both sides of this street to near the Bay, and down Union Street to Broad Street, burning both sides…many wooden buildings were blown up to arrest the progress of the devouring element. The blowing up of the house occupied by Mr. Chupein, in Broad Street, above Union Street, was the means of preventing the further extension of the flames…

The water in the wells held out much better than could have been expected, considering the draught of the season…great and well-grounded complaints are made by the citizens against those idle and useless men and boys, who, during the raging of the fire, when the scene should rouse the indolent disposition, are in the habit of approaching it on horseback, to the great danger of those active citizens who are exerting themselves in defense of the lives and property of their fellow creatures. We do not know whether there is an ordinance on this subject, if there is, it should be rigidly enforced by the militia…

The bones of a female were yesterday discovered among the ruins of Union Street. Several persons received injury pulling down the houses… the loss of property cannot as yet be accurately ascertained…the number of houses which were burnt and blown up are about two hundred and fifty…bread and meat were yesterday distributed among the poor sufferers…a large proportion of the houses destroyed were either owned or occupied by persons in the humbler walks of life, many of whom have been deprived by this awful calamity of their little all.

This morning about 7 o'clock the citizens were again alarmed by the cry of fire. It proceeded from the stable loft of Col. Sass, in Queen Street, but was fortunately got under before any material injury was sustained. There remains not the least doubt but this last fire was the work of some wicked incendiary, as a quantity of live coals were discovered among the hay, evidently placed there by design. Several Negroes have been arrested on suspicion, and are now undergoing examination.

By 1815, Charleston had enacted an ordinance providing for supervisors for city fire engines, together with a crew of at least forty slaves. Wages for time spent actually fighting fires were set, and a bonus was stipulated for those first on the scene. The monetary incentives would hopefully bring men and machines to a fire more promptly. Neglect of the building codes left plenty of wood to burn in rapid fashion.

By 1819, Charleston was suffering a complete reversal of economic fortune. Too much American cotton was being produced, causing a drastic decline in prices per bale. Charleston found itself in competition with new

ports on the Gulf Coast. Local retail business, closely tied to cotton and trade, was stagnated. On July 6, a fire broke out at Meeting and Market Streets, causing a great deal of destruction in the commercial district. The *Charleston Times* posted the following notice, aware from experience that the confusion of a fire created the perfect opportunity for people to pilfer:

> *The sufferers by the late fire earnestly request all persons who may have any articles in their possession (not their own) to send them to Mr. Pearce's Long Room, No. 86 Meeting Street—or if inconvenient to send them, to give information at the above place, in order that each person may have an opportunity of collecting their own.*

Though no official record survived noting how successful the campaign was, the pending economic decline made it unlikely that much of the lost merchandise found its way back to its respectful owner. As the market economy shrank, one commodity was abundant: fear.

The 1820s saw white trepidation multiplied tenfold as every suspicious fire, no matter how small, was blamed on black incendiaries. The movements of slaves within the city were more tightly regulated than ever. Laws were passed to regulate black seamen while they moved about Charleston's port. The jail on Magazine Street, built in 1804, was joined next door by the newest incarnation of the workhouse for incorrigible slaves, complete with a treadmill. Corporal punishment for even minor crimes was severe if the suspect was black.

The Charleston District Jail had held the principal participants of a supposed slave uprising centered on a man named Denmark Vesey. Rumor, hearsay and innuendo placed the noose around the neck of several black men, Vesey included. Historians debate today whether the revolt was real, or whether the entire episode was Charleston's answer to the witch trials of Salem. *Very* real, though, was the all-consuming terror in the minds of white Charlestonians convinced that crazed Africans would murder whole families as they slept.

In 1825, a permanent arsenal was under construction near the lines of fortifications in the Neck; its main purpose was to serve as a strong visual deterrent to any person of color intent on insurrection. This "Citadel" eventually displayed stacked arms and cannons, which symbolized the strength behind the ruling status quo. Soon even the militia could not give the people of Charleston the security they needed, as fires became an everyday threat.

To increase their mobility, the City Guard was given several horses. The mounted patrol joined the militia and groups of ordinary citizens who kept watch for the first sign of smoke. Of the many fires that occurred in 1826,

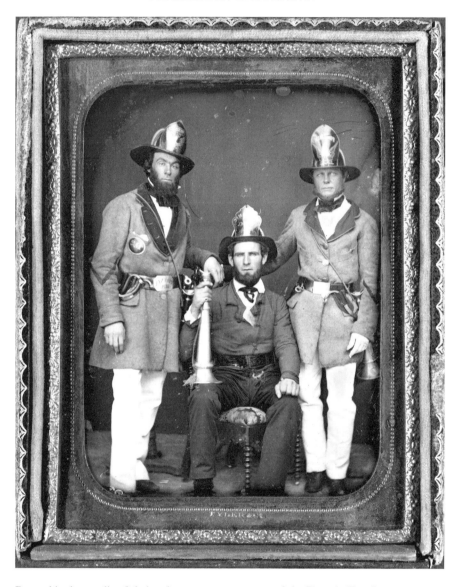

Dressed in the regalia of their volunteer company, men of the Phoenix Fire Company show the look of determination needed to do the work of a fireman in nineteenth-century Charleston. *Library of Congress.*

the cry of "arson" arose more often than was justified by the evidence at hand. Fire did have other causes, including the carelessness of white folks. "Black arsonists on the prowl" relieved these people of responsibility and gave the whole of Charleston a common foe to unite against. On Saturday morning, June 26, 1826, a fire began in the house of a white businessman.

Two Centuries of Fire and Flames

A double two-and-a-half-story frame tenement owned by Mr. Joseph Flemming was situated on the west side of King Street, only a few doors above Boundary Street. The property was rented to Mr. John Conner, who worked as a saddler there. The *Charleston Mercury* recorded several other losses on West King. Another two-and-a-half-story house rented to a shoemaker named Suraw was lost, as was a cabinetmaker's shop, a grocery and a dry goods store.

On East King, three dwelling houses, a chair maker's shop, a hatter, a weaver, three dry goods establishments, a grocer and a confectioner were all burned out of business. All told, at least thirty houses, with many other outbuildings such as kitchen houses and privies, were destroyed. A contemporary estimate of the loss was placed at $100,000.

The *Mercury* summarized the June 26, 1826 fire:

> *The devouring element, impelled by its violence, soon crossed over to the east side of King Street. It also extended down Boundary Street as far as the Orphan House, which noble institution was for a time in very imminent danger...imagination can scarcely conceive the fury and impetuosity with which the destructive element advanced...whether it arose by accident or design has not been ascertained. One man was severely mangled, we are informed, by the explosion of a house, and several others more or less injured.*
>
> *All possible praise is due to the zealous exertions of our citizens generally, and particularly to the labor and efforts and manly intrepidity of the different Fire and Axe Companies.*

As there was only one "Fire Company of Axemen," it appears that the *Mercury* used a generic term to refer to the existing volunteer companies in service at the time. In 1826, Charleston boasted of the Axemen, the Vigilant, the Eagle and the Phoenix Fire Companies, as well as one named after the city itself. The hand-pump engine was still the most common machine used by all the companies to put water on the fire. In 1829, the Aetna Fire Company was chartered, bringing the number of volunteer companies to six.

THE MARKET FIRE
OF 1833

The 1830s saw a continuation of Charleston's financial difficulties. Politicos debated the state's right to nullify any action by the Washington government that was interpreted as a dilution of sovereignty. Quite to the contrary, President Andrew Jackson's mind was instead focused on a union of states whose wills were subjugated to the central government. As the debate raged, Charleston became content to laud its very existence on slavery, despite the city's lack of adequate rail or port facilities.

Charleston's economic decline meant an increase of inmates in both the Charleston orphanage and the poorhouse. Idleness, drunkenness and sexual exploitation were the habits of the poor, both black and white. Though relief, in the form of food and clothes, was regularly doled out by various churches and societies, most of this effort was directed at the white lower class.

Blacks, both freemen and slaves, were set apart as a separate class to be dealt with, always with a cautious eye toward the perceived tendency of the race to riot and rebel. Before his death in 1828, Charlestonian Thomas Pinckney had gone so far as to suggest that the city should give up its domestic slaves in favor of cheap Irish labor. These recent immigrants would be grateful for work but would not pose the security risk that was ever-present with the Africans.

On February 18, 1833, cries of "fire" roused the populace to action as a wave of smoke and flame began to roll over the market. Close on the heels of the alarm, the rumor of "arson" began to spread right along with the destruction. Charleston's *City Gazette* summarized the event, providing its readers with a very precise description of the fire's origin:

CHARLESTON IS BURNING!

Our city was alarmed for the first time this year by the appalling cry of fire. It burst forth with a terrible volume of flame, from a small tenement in East bay, the second door between the North Corner of Market and Ellery streets. Many of the contiguous buildings being little more than a mass of combustibles, the flames extended with unparalleled rapidity… the wind was rather high, and whilst it prevailed from the south mast, large flakes of burning cinders swept entirely across the most compact and populous part of the city…the roofs of several houses in Meeting, King and other streets, some of them half a mile or more from the scene of conflagration, were frequently ignited by the burning flames which the wind conveyed in its course. Fortunately, the decisive measures adopted by the Fire Department in blowing up and prostrating several houses, and the laborious and praiseworthy exertions of the different Fire Companies, were crowned by success. At about 10 o'clock the progress of the devouring element was arrested, leaving the entire square bounded by East Bay, Market, Anson and Ellery Street, including all that part of the Market House between the junction of State and Market streets, a heap of smouldering ruins…the large block of wooden tenements on the South side of the market, facing the square ravaged by the fire, was at one time in flames—but owing to the skill and perseverance of the Vigilant Company, with their hose, drawing an inexhaustible supply of water from the docks, that square was saved.

This narrative illustrates the early but emerging contributions of the Charleston Fire Department, a slowly evolving agency of municipal government. Strictly speaking, the city department was completely separate from the volunteers, but the point was quickly lost as they joined together to fight the fire.

The city department consisted of the fire masters who were responsible for deciding which structures would be blown up to arrest a fire's advance. This department also included any pump apparatus, ladders or buckets paid for by the city (but manned by slaves). Blacks were only allowed to use city-owned equipment; slaves had white supervisors who oversaw the struggle to drag the engines to a fire. The work of these blacks was then coordinated with the efforts of the volunteers by the fire masters on the scene. Masters would bellow orders through their trumpets to volunteers and slaves alike.

The eventual control of this particular fire in early 1833 was credited to yet a third group of responders, who joined fire masters and volunteers alike in their firefighting efforts: soldiers and sailors stationed in or near Charleston. The *Gazette* highlighted their contributions:

Two Centuries of Fire and Flames

As soon as the fire was discovered at Ft. Moultrie, Col. Bankhead, accompanied by several of his officers, and a large detachment of troops under his command, and Capt. Zantzinger, from the Sloop of War Natchez *with a fine detachment of seamen, all repaired to the scene of conflagration with the most extraordinary alacrity. Men were also furnished from the Cutter* Albert *and from other shipping in the port. But the services of the brave* [men] *from the* Natchez…*were appreciated in a very special manner. They worked the Engine* [of the Vigilant Fire Company] *like veterans—and show themselves as prompt and efficient to save the property of their countrymen on shore, as they are to protect and defend it upon the great high way of the world.*

No fatalities were reported, but the *Charleston Mercury* newspaper reported on February 18 that

Mr. McIntyre of King Street was severely injured in the thigh by the fall of one of the buildings—and a black man, the property of Mr. Howard, bricklayer, was very seriously injured by being run over by an Engine, the wheels of which passed over his breast, and fractured the bones of his shoulder.

In this same issue of the *Mercury*, the following acknowledgement was printed:

At a meeting of the Vigilant Fire Engine Company, held after the fire on Saturday night last, it was Resolved unanimously *that the thanks of the Company are due and are hereby tendered to the Officers and Crew of the U.S. Ship* Natchez, *the Revenue Cutter* Albert, *to the Officers and Privates of the U.S. Army, and to the Captain and Crews of the Line Ship* Niagara, *for the prompt and efficient assistance rendered by them to this Company at the fire in Market Street.*

Almost two years later to the day of the market fire, reminders of ash, soot and debris were burned into the memory of every Charlestonian for generations to come. The all-consuming nature of these next fires caused many locals to consider the worst. Perhaps Charleston was a city whose days were numbered.

Slaves, seamen, fire masters and soldiers—odd teammates except in times of dire emergency. Repeated calls for the construction of fireproof buildings continued to be met by the tempering concern for the high cost of such construction. Charleston had from its first days been an amalgam of wealthy, working class, poor, freedman and slave. Many of the better class had built in brick, only to find their houses gutted to the walls by the most recent incident.

The rest of the city's people made do in wooden shacks and lean-tos. With waves of emigrants from Ireland and Germany swelling the ranks of the poor and homeless in Charleston's streets, the prohibition of wooden dwellings was simply impractical. If improvements to the construction process were not the answer, then maybe the solution could be found in the way that the fires were fought. In a port city teaming with taverns, brothels, slums and unregulated commerce in such commodities as turpentine, perhaps fire was just inevitable. If so, then the City of Charleston was responsible for seeing to it that an adequate and well-equipped force was standing by to respond.

THE DISASTERS OF 1835

The first months of 1835 found Charleston deep in financial depression. The usual traffic flow of sailors back and forth to the bordellos was now supplemented by the occasional merchant or clerk. Each man in turn sought temporary relief from those things in life that he could not change. For the sailor, it was the weeks and months of solitude under sail. The local businessmen suffered from the anxiety of a continued decline in profits and the resultant effects on their families. The local police turned a blind eye to them both, much more concerned about keeping the "darkies" in line. Though these "houses of ill repute" could provide some "escape from reality," there would be no such thing on the morning of February 16, 1835.

The *Southern Patriot* newspaper spared no sentiments in identifying the origin of the fire:

> *Our city was alarmed between the hours of 1 and 2 o'clock yesterday morning, with the appalling cry of fire, which was found to proceed from the wooden dwelling which stood at the North West corner of State and Lingard streets, in the occupation of CORNEL JUNE, as a house of ill fame. The flames spread with extraordinary rapidity on all sides, involving in destruction the greater part of two squares...in Church Street it consumed from the corner of Amen street to St. Phillips Church, including one of the large livery stables on this spot, occupied by Messrs. Chapman & Bufort, having in it a large quantity of fodder. The horses were fortunately saved.*
>
> *The blowing up of the large wooden house which stood at the N.E. corner of Amen and Church streets prevented the fire from crossing this latter street. This most judicious expedient, with the large open spaces formed by the burial grounds of the St. Phillips and the Circular*

CHARLESTON IS BURNING!

Churches, saved a large part of the city to the South West. The roof of Mr. Lege's Long Room, situated near the junction of these burial places, with the dome of the Circular Church and some wooden tenements on Queen street were repeatedly ignited from the number of sparks and flakes of fire that the high wind carried in that direction...but the most melancholy feature in the catastrophe is the destruction of St. Phillips Church, the oldest public edifice in the city, having been built in 1723.

For the first time, Charleston lost something that could not be replaced in the hearts and minds of the current generation or those to come. A church built to the glory of God and the eye of the beholder, it was a structure of such strength and beauty that its demise shook Charleston to its very foundation. Immediately, there were charges that the stately old temple had not been properly defended against the flaming onslaught. The *Charleston Mercury* addressed this issue, whereas the *Patriot* did not:

It was discovered that the dome of the steeple of the "Old Church," St. Phillips, on which a spark had fallen was beginning to blaze. Either from a false confidence or some other cause, it appears that the proper measures for the preservation of this remarkable and beautiful edifice had been neglected. There was no person on the roof of the cupola, as it was presumed by most spectators that there must, as there ought to have been, to prevent its being kindled by falling sparks, and when the fire had made some head, and there were attempts to get at it, these were rendered futile by the dense smoke which filled the interior of the steeple. We had the mortification therefore of beholding the domes burn slowly downwards, and then fall in with a crash which was succeeded by a magnificent burst of fire from the tower, which continued for more than an hour to send up volumes of flame like the crater of a volcano, until at last the body of the Church and the whole roof kindled at once, and the destruction was complete...Everyone felt its fall, that a link was harshly sundered in the chain of his cherished associations—and we have seen more than one among the old and the young who have wept over the noble ruin.

A circular printed by Reverend C.E. Gadsden, the rector of St. Philip's at the time, summed up the disaster:

It has pleased Divine Providence to permit us to be sorely afflicted. The countenances and demeanor, not only of our own members of every class

50

and caste, but of our fellow-citizens generally, announce a public calamity. Our holy and our beautiful house...is burnt up with fire and all our pleasant things are laid to waste.

The damage in the area near St. Philip's Episcopal Church was just as severe. The *Southern Patriot* went street to street, assessing the damage:

Market Street: Peter Joshua, Grocery Store, (not insured)...loss considerable. J. Jianni, Fruit Shop...no insurance, loss severe. P. Santini, Fruit Shop, considerable damage...to the stock.

State Street: 3 or 4 houses occupied by Negroes between the corner of State and Market streets and the house owned and occupied by C. June at the corner of Lingard and State streets, where the fire originated. The opposite corner to June...occupied by Mr. Johnson as a Grocery Store, lost all, no insurance on the stock...the Blacksmith Shop...was owned and occupied by Mr. Scanlan, not insured, loss considerable.

Amen Street, North Side: The three story wooden house owned and occupied by Mrs. Dukes, as residence, no insurance, lost all furniture...a three story wooden building, occupied by Mrs. Fabian, at the N.E. corner of Amen and Church, as a boarding house...blown up.

Amen Street, South Side: a house at the S.E. corner of Amen and Church Street, occupied as a barber shop by a coloured man, owned by a coloured woman, no insurance.

Church Street: A wheelwright shop owned and occupied by Mr. Hamill, no insurance, lost everything. The large stable occupied by Messrs. Chapman and Bufort, was totally destroyed.

Three months later, on June 6, 1835, another fire burst forth just north of the previous destruction. Again the firemen were taxed to the limits of their labor, and cries soon uttered forth for changes in the Charleston Fire Department. The *Mercury* tracked the flames from block to block:

It has indeed been a tremendous conflagration—having swept everything in the district of the city bounded North by Hasel street, East by Anson, South by Market and West by Meeting streets...in the thick nest of wooden buildings the progress of the fire towards the river was arrested by the blowing up of a house. The Methodist Church on Hasel street was saved by the blowing up of Mrs. Thompson's house at the corner of Maiden Lane...by great exertions in pulling down the roof of the Beef Market which was burning, the fire was prevented from crossing to the South of

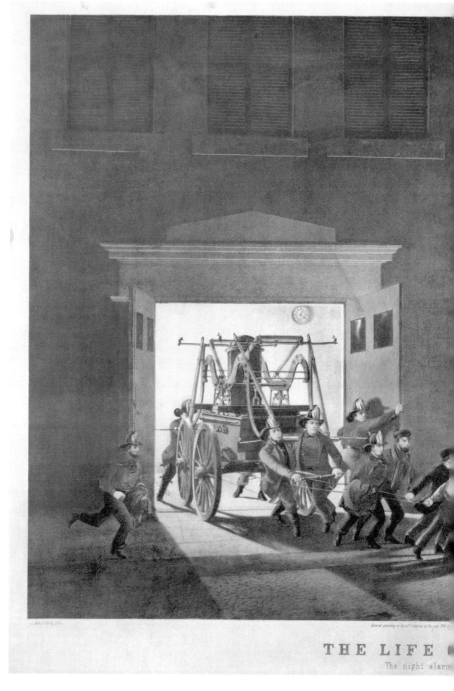

THE LIFE

The night alarm

Perhaps the hardest part of fighting a fire was actually getting the fire engine in place. Rival volunteer companies often held competitions to see who could drag an engine the fastest from one point to another. Proud of their physical prowess, the

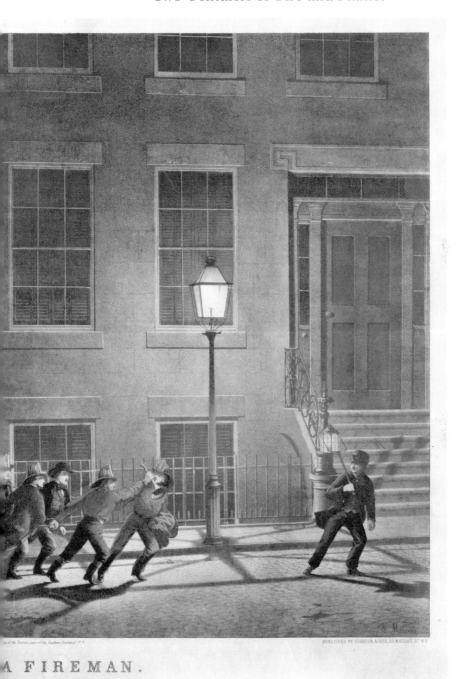

A FIREMAN.

her lively boys'

use of a horse or mule would have suggested laziness to the early men of the fire service. *Library of Congress.*

Market street. Great praise is due to the firemen engaged in this quarter, to whose energy and perseverance we take pleasure in bearing testimony.

…The number of houses destroyed is estimated at not far short of THREE HUNDRED; *and the pecuniary loss at from three hundred and fifty to four hundred thousand, or perhaps half a million dollars…of which a very heavy portion thus falls on those least able to sustain it.*

The several fire companies used their best exertions, but their efforts were for the most part frustrated by the deficiency of water. Of many of the houses blown up, the blowing up was too long deferred. It was evident that the Engineer to whom that duty is entrusted, is not provided with a sufficient number of assistants. Nothing but the blowing up of houses stopped the fire in three different quarters; and in a city unprovided with hydrants, it is all important that this department be strengthened, and greater power given to the Engineer than he can now exercise. He is often obliged to wait for orders, and may be delayed by the vacillation and imbecility of those from whom the orders are to be received, until it is too late to save long ranges of valuable buildings which common energy and promptness could have preserved. A great mistake also prevails among many that the insurance is forfeited where a house is blown up. This is an error which we understand the Insurance Offices will take measure to correct.

The complaint is general and loud against the inefficient organization of the Fire Department, as evidenced at both the last great fires; and we doubt not that the Corporation will apply themselves to remodel and reform the system, which as it now works, is really discreditable to the city.

The editorialized reality of firefighting was sinking deeper and deeper into the minds of Charleston's people; perhaps the collective conscience had had enough. Two raging firestorms had transfigured the peninsula's landscape. Gardens and gateways were clogged with charred debris, while the smell of smoke sat heavy over the city with the stillness of summer. Later in life, Frederick Adolphus Porcher would record his memories of the second fire of 1835. As bad as things were, they would soon be worse:

I think it was the night before I left, that a fire broke out in Meeting street which was the greatest ever before known in Charleston, but which is completely forgotten in consequence of the great fire of 1838 which occurred nearly three years afterwards.

Charleston historian Mrs. St. Julian Ravenel quoted the unknown author of a "contemporaneous letter" that brought further scrutiny to the collapse of St. Philip's:

> *But St. Phillips! The least exertion would have saved it, one good head might have saved that noble building. Nothing was done however. They stood and watched it burn to ashes. The steeple caught first, one wet blanket could have extinguished it. But though there were hundreds of sailors in port, nobody thought of sending a few up to the roof to smother the one spot of flame. That one spot spread wreathed slowly round, and finally burnt the church to the ground without one single effort...but on the former occasion, Mr. Frost (then rector) offered a great reward & it was saved!*

St. Philip's had indeed been saved before as cinders spread over its roofline and steeple. Based on Mrs. Ravenel's letter and the content of the *Mercury*, there remains the question of why there was no preventive action to save the church. Maybe the absence of a reward prevented anyone from rushing to the church. If rewards were the sole inducement to save the structure, then Rhett's take on Boney's actions in 1796 makes better sense.

Setting speculation aside, the outcome is nevertheless clear: in the absence of any auxiliary forces, the manpower of the fire department and the volunteer companies was terribly unprepared for a fire of this magnitude. If they had hopes of being reinforced by the army or navy, those hopes went with the wind as the fire multiplied. Standing alone, the firefighters of Charleston were no match for the whirling and churning mass of destruction that left Church Street a blackened hollow.

IMPROVING THE DEPARTMENT

The year 1837 was one of economic renewal for Charleston. Business was better for just about everyone, especially the artisans in the building trades. The fires of 1835 had left much to be taken down and replaced, leaving room for new stores and residences. The shock of the double disasters had just begun to dwindle when, barely two years later, flames seemed to spring unannounced from almost any and every quarter.

On March 22, 1837, fire engulfed a shed next to a residence on the lower end of Church Street. The *Southern Patriot* suggested the fire had been deliberately set.

The same newspaper then reported a fire on March 23, 1837, pouring from the forecastle of a ship docked on the Cooper River at Vanderhorst Wharf. Loaded with turpentine and cotton, an explosion could level much of the oldest portion of the city. Local sailors and dock workers were fortunate to bring the fire under control just as the suspect dashed from the ship and jumped into the water, escaping to another pier farther upriver. Once again, the threat of arsonists was common talk in taverns and on the wharfs.

The *Patriot* acknowledged the rumors, suggesting the fires were simply a diversion:

> We have heard of various other attempts of late to set fire in different parts of town, and the public authorities have with due vigilance adopted measures for the protection of the city, so that the incendiaries will be deprived of the hope of plunder, which no doubt induced these attempts.

Local papers soon found that the hue and cry over the condition of the fire department could fill a front page. Charleston's city council was bombarded

by comments from ordinary citizens, businessmen and the fire volunteers themselves. Council served as the conduit through which the city fire masters, the volunteers and the Charleston Fire Department communicated. Unfortunately, it was this very triumvirate of separated entities that served only to compound the dilemma of mounting an effective effort to prevent and suppress fires.

The *Courier* reported on April 4, 1837, that a resolution was passed by city council to make three hundred copies of the current fire regulations. These would be distributed by the fire masters despite the fact that for well over a century the public had been well informed of the regulations concerning combustibles, chimneys and fireproofing but consistently chose to ignore the dangers.

It was not unusual for a fine to be levied for keeping combustibles too close to a dwelling, only to have council excuse the fine based on hardship considerations. This most recent attempt at educating the citizens of Charleston proved to be a simple waste of effort.

On May 10, one of Charleston's oldest volunteer companies, the Vigilant, came before city council to request the sum of $1,200 to repair its current station and to add an addition. The *Southern Patriot* then reported that on June 27, the fledgling Neptune Fire Engine Company asked council for use of the old Vigilant station, as council was then considering the removal of Vigilant to a new location.

On June 27, council also heard an appeal from Lauren Ryan, who "prayed relief for a fine levied for a chimney fire." The request was later granted, diminishing any punitive effect the fine may have had on the homeowner. At this same meeting, the fire masters discussed an amendment to an 1815 ordinance that governed the payment of premiums to responding volunteers.

By the fall of 1837, there was a concerted effort to find suitable land for more firehouses. This effort was led by Robert Y. Hayne, the first person to be called "mayor" after the title "intendant" was dropped in 1836. Patrick Cantwell had petitioned for the demolition of the Vigilant station at East Bay and Boundary, based on its deteriorated condition.

On September 26, one week after Cantwell's request was printed, the *Courier* published a long commentary by Mayor Hayne, who acknowledged not only the need for new stations but also a need for land on which to situate the buildings. Hayne directed council members to personally approach certain property owners about the use of their land toward that end. The mayor made it clear that the use of the land for construction of a firehouse should be unencumbered by expense or rent. The obvious quid pro quo

was that the same property owner would have the resources of the firehouse immediately at hand.

On October 10, the paper printed a request to council from the Aetna Fire Company. The volunteers asked for the necessary funds to buy a lot for a firehouse at Church and Market Streets. As if to set the example for the rest of the community, the Aetna indicated that the house would be built of brick. October 31 saw a request from the board of fire masters for new lengths of hose for one of the volunteer companies.

These cooperative efforts to improve fire services to the city of Charleston continued into 1838. On March 12 of that year, the *Charleston Mercury* reported on a fire inspection in the city:

> *The committee on combustibles had examined the steam establishment of Mr. Gibbes and Mr. Williams at the west end of Tradd Street and found it as safe as such an establishment could be made.*

It seemed for a time that the preventive efforts, combined with improvements to the fire department, had paid valuable dividends. The horror of flames engulfing blocks of Charleston at a time had faded from the minds of most folks, though doubtlessly some accepted incineration as a fate they may not escape.

In a 1978 journal article, "The Blood-Thirsty Tiger: Charleston and the Psychology of Fire," the reality of dealing with the almost daily threat of fire in nineteenth-century Charleston was discussed:

> *Experience had proved that almost anything could start a fire. An illuminated kite could fall at night and bring fire. Small boys could pour turpentine on a cat's tail, light it, watch the cat scurry into the stable, and then realize that it had set the hay on fire. A man could trip on the stairs, drop his lantern, ignite his house, and gut several city blocks. As causes seemed infinite, so the ringing of fire bells sometimes seemed unceasing. Most Charlestonians had witnessed fires in the past and feared them in the future. Yet their very frequency dulled their impact.*

THE DESTRUCTION OF ANSONBOROUGH, 1838

O n March 28, 1838, fate dealt Charleston a ruinous hand. The *Mercury* gave a full accounting of the disaster as it unfolded:

We have to delay our paper to a late hour this morning, on account of a most disastrous FIRE which has been sweeping resistlessly all night through the very heart of our ill-fated city. The fire broke out at Sutcliffe's bakery, corner of Swinton's Lane and King street, on the west side of the latter, at about half past 8 p.m...owing to the southwest wind the progress of the flames was arrested, but to the North, North West, North East, and East, the fire was sweeping widely and furiously...as far as the corner of Meeting and Market streets. It has crossed Meeting and was raging down the south side of Market street. It had burnt up to and crossed Market street on both sides of King street...the beautiful new theatre is partly destroyed. The scaffolding and woodwork of the new Masonic Hall at the market was on fire...the firemen and engineers have labored to exhaustion, but it would be impossible for a hundred times their force to encounter successfully such a fire. Buildings in great number have been blown up during the night until the supply of powder failed...

Two O'clock. The fire is still raging, and that splendid edifice, the new hotel, with the range of new stores on Pearl street are all in flames. The fire has also extended up King street as far as Wentworth street, sweeping everything before it...

Half past Two...If stopped at all before it reaches the wharf, it must be at State street...

Five O'clock...The fire still continues to burn with little or no abatement. It has extended to the North East as far as Bennett's Rice

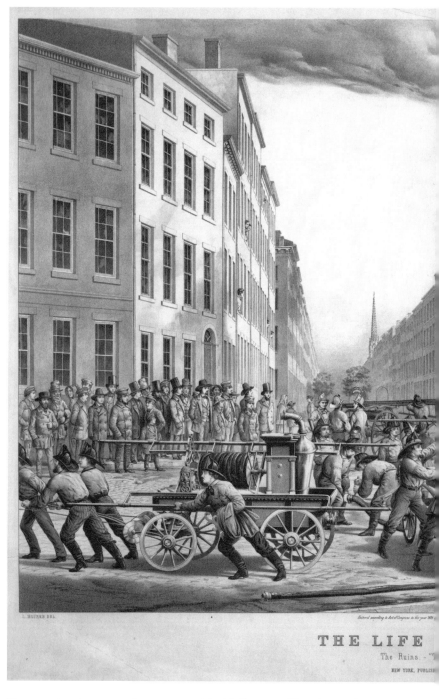

L. MAURER DEL.

Entered according to Act of Congress in the year 1858

THE LIFE

The Ruins - "

NEW YORK, PUBLISH

Numerous hand-pump engines are at work in this fire scene. Note the number of hands necessary to operate the machine, while other firemen aim hoses or man the rescue ladders. With no other engines in use at the time, Charleston's

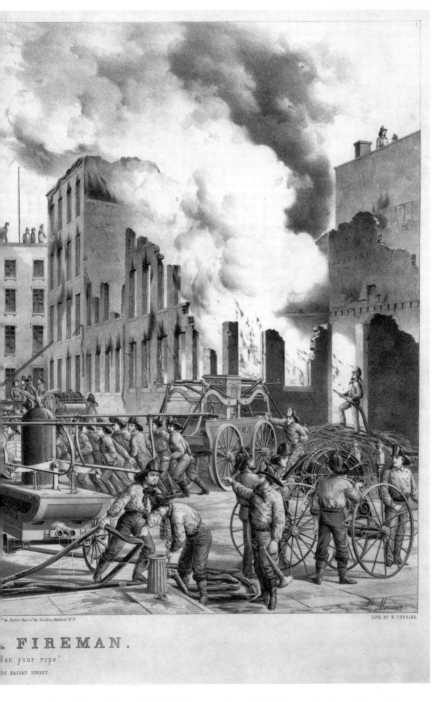

Ansonborough would be laid to waste by a fire that was simply unstoppable.
Library of Congress.

Mill…Society street is one mass of flames from East Bay to within a few doors of King street.

Pearl Street, Hayne Street today, was an example of the expansion and growth of Charleston through and beyond the old burned-out district. There, a series of stone, mortar and brick buildings was erected as a tribute to the enduring character of a city willing to rebuild with fireproof materials. Such fireproofing had proven costly in the past, and so again the public turned to the least expensive supply of lumber they could find to join in the rebuilding of the area around the market. Wood burned, and so did the interior of the sturdiest brick structure. Pearl Street became a bone orchard of burned-out skeletons, walls and chimneys, standing in mute testimony to the absolute devastation that surrounded them.

Several persons died in the fire. The *Courier* listed "Mr. Robert Monroe having either been burned up in his store or some part of the ruins falling on him. He was most dreadfully lacerated and dismembered." There was a white man who "it is believed died from mere fright or perhaps from apoplexy."

Wagon loads of artillery charges were brought from the armory, and when they were depleted, whole barrels of gunpowder were used. Two individuals perished while laying charges of gunpowder to blow gaps in the fire. Frederick Schnierle was assistant chief of the Charleston Fire Department. Colonel Charles John Steedman was a planter, legislator and former sheriff of Charleston District.

The *News and Courier* gave this historical account of the death of Chief Schnierle:

The bagged powder gave out early, and kegs of powder were substituted. These sometimes leaked, required fuses, and had far greater explosive force than the caisson charges. Firemen and volunteers rolled and trundled them into houses often already on fire, set fuses hastily and doubtless, often clumsily, and ran for it. But kegs went off ahead of time…

The assistant fire chief was fatally injured when a keg in a house at Liberty and King Streets exploded too quickly. Buried in its ruins, Schnierle spoke calmly to his rescuers as they dragged him out, burned, disfigured but still conscious. He died at home half an hour later.

The account of Steedman's death, in the company of several helpers, spoke of the terrible suffering that he must have endured:

Steedman's house at the corner of Meeting and John streets was in no immediate danger…he entered a house on the east side of East Bay near Hasell Street, accompanied by several helpers, including Mr. M.F. Turley, a colored boy, and Capt. Duff, of the ship "Herald," then in port. The dangerous charges were placed upstairs and down, while Duff for some reason climbed up on the roof. Steedman, Turley and the boy were all inside when the first keg went off.

Rescuers reached Turley first, finding him blinded and with a broken arm. Before Duff could come down or Steedman and the boy be reached, the second keg exploded, lifting the roof and the captain high in air. Duff, however, miraculously escaped injury. The diggers had hoped that Steedman was still alive, since they had heard him call out after the first explosion. But when they dragged the big man out, he was lifeless and unrecognizable. Flames that shot through the house prevented recovery of the servant's body.

Mayor H.L. Pinckney and members of city council attended the funerals and supported the motion to erect monuments in their honor. The epitaph to Colonel Steedman hailed the demise of a hero. The tall obelisk, situated on the western side of St. Philip's burial ground, preserved the nature of the inferno for posterity:

To the memory of Colonel John Charles Steedman…who perished on the 28th day of April, A.D. 1838, in the fifty-sixth year of his age, a martyr in the cause of humanity. During the awful conflagration of that morning and the previous night, which laid in ruins nearly a third part of Charleston, having met his death by the premature explosion of a keg of powder while engaged in reparation for blowing up a house to arrest the progress of the flames.

A volunteer fireman by the name of John Peart also died while blowing up houses. According to the *Charleston Courier*, Peart was "thrown against something and inwardly injured, as there did not appear to be any wounds externally that would have proved fatal." Peart's funeral services were ignored by council. This affront to Peart's dignity and dedication to duty did not pass unnoticed by the public. The *Mercury* printed one person's outcry on May 17, 1838:

Let me ask every man who is possessed of a sound and discriminating mind if such neglect as that has a tendency to inspire the young men of this City to acts of valor and heroism? Will any young man, seeing the neglect with which his fallen brother has been treated, rush forward at the hazard of his own life, to prevent another's property from being destroyed?

CHARLESTON IS BURNING!

The historical record of the 1838 fire is very strong. Letters and a diary provide stirring first-person accounts. That these persons took the time to record their experiences speaks to the emotional impact that they felt. Daniel Cannon Webb's diary gave a door-to-door account of the fire's path, including the destruction of the newly completed Charleston Hotel on Meeting Street:

> This is an awful and most memorable night. The greatest fire ever known in Charleston commenced at 9 this evening…it began at NW corner of Beresford and King, burned both sides of Beresford to Archdale, 3 or 4 doors south of Beresford, in King street and every building to Society street on one side to Liberty and on the other moving west in every street near to Beaufain and St. Phillip's Street but not reaching either, Society Street's whole south side to Mr. Nat Heyward's house, whole north side from Meeting street to bay—Wentworth, both sides, every house from between King street to St. Phillip's to East bay except NW corner Meeting street—Hassell street south side, every house including Catholic Church to East Bay—North side from King street, synagogue—skipped two brick houses, next its every house, except Mr. Stoney's to the Bay…
>
> Meeting street west side from Theatre (saved) every house to Society street except one, corner Wentworth—east side every house from ice house (saved) to 2 or 3 beyond Society street—Anson street from the sugar refinery to St. Stephen's chapel on west side—and to Universalist Church on east side—the splendid Charleston Hotel, just about completed, the master had moved his family in and lost everything…at a cost of $250,000 it had been erected—four churches and one meeting room were destroyed—at 2 points in Anson street churches arrested the fire—on East bay every house from Hassell to two houses N. of Society…
>
> Language cannot convey to the absent the awful desolation which has laid way to our fair city.

Mr. A. Fowler initiated a letter to Mr. Mitchell from Christ Church Parish on May 8, 1838. He too spoke of just how extensive the damage was:

> We have had in Charleston the most tremendous fire that ever took place in that city and it will be many years before it will recover its loss. The spectacle it now exhibits is truly melancholy and awful. Had the wind changed in the night of the conflagration, it would no doubt have destroyed all the lower part of the city. You can form no idea of the destruction that has taken place, and of the distress of the people. The want of water has

The Charleston Hotel was known to generations of Charlestonians for the fine quality of its accommodations. The first Charleston Hotel, on the same site, burned in the Ansonborough fire of 1838. *Library of Congress.*

become alarming and it was surprising the fire stopped where it did. We had a view of the fire in our parish, and the light was equal even here to that of the full moon; we could hear the bells ring and the noise of the engines.

With pen in hand, Mr. Josiah Bailey described the awe and shock of the fire to Mr. Neilson Poe, editor of the *Chronicle* newspaper of Baltimore, Maryland. While he does explain the lack of water to which Fowler referred, Bailey's main concern was that his dramatic take on the fire would be sufficient to prompt a public appeal for aid:

CHARLESTON IS BURNING!

With feelings so harrowed that my pen almost drops from my hand, I hasten to inform you of a conflagration that for its extent, its unutterable horrors and misfortune has no parallel in this country. A long period of drought producing scarcity of water and much combustible material for the devouring element gave it an intensity, that it spread over near one-third of our city with a rapidity unequalled to any thing I every witnessed. Square after square was demolished with a speed almost electrical—the conflagration appeared to defy all contrivance and paralyze all energy in its extinguishment. The misfortune appears to be almost irreparable. The future prospects of Charleston had taken such rapid strides within a short time back, for its commercial fortunes & consequent increase of population, & now in so short a time, to be succeeded by distress that knows no mitigation, is to me a task that I cannot undertake to describe...

Would it be advisable for you to call publicly through your paper for a town meeting to do something.

The perceived failure of this amalgam of men, loosely referred to as the Charleston Fire Department, generated another round of condemnations and calls for change. One option discussed was to put all of the volunteers under one chief. The very nature of the volunteer companies prohibited this, as each company elected its officers through a democratic process. In February 1839, Charleston City Council approved an ordinance establishing the position of chief engineer, with an annual salary of $2,500.

The full-time engineer was responsible for maintenance of all fire engines and equipment. At a fire, the engineer was the man in charge to direct the slaves and the volunteers. The fire masters continued to make policy, but the actual direction of men and material to put out a fire yielded to this new position. The council in the meantime turned its attention to the construction of the necessary wells and cisterns to provide for an adequate supply of water with which to extinguish the flames.

As fire companies were composed largely of artisans and other common men of Charleston, the status of a volunteer fireman was derived from his perception of an autonomy that shrouded his company and whatever equipment it had assembled. In fact, most such equipment and the very stations the volunteers gathered in were paid for by city funds.

Regardless, the sight of the chief engineer strolling right into a station and rummaging about the hoses and axes embittered the volunteers. Up to this time, their stations, not unlike a Masonic temple, had been hallowed spaces, where the men of the company participated in their fraternal and ritualistic ceremonies. Now, that space had been violated by an outsider.

Two Centuries of Fire and Flames

The *Charleston Mercury* took a vested interest in supporting a return to the status quo. The paper supported a move that would see the fire masters return to their previous numbers, divested of any subordination to the chief engineer. The volunteers were encouraged to hold fast to their unique traditions. A referendum vote on the fate of the department's organization brought events full circle.

Though public voter turnout was not strong, the end was hailed as a general victory for the ordinary citizens of the city. The social institution of volunteer firefighting was preserved, while genuine concerns about the actual efficiency of the department quickly dissipated like smoke in the face of the city's sea breezes. Human carelessness continued to abound, while cries of "arson" and "incendiaries" displaced responsibility to blacks from all walks of life. The fear of insurrection continued unabated, finding root in tall tales and rumors. As soon as St. Michael's chimed ten o'clock at night, blacks retreated to their homes as the drums rolled at the police headquarters across the street. Charleston would now take it one night at a time, with one eye shut and one eye on the candle.

Reverend Thomas Smyth delivered an address at the Second Presbyterian Church on May 6, 1838. Smyth reflected on the recent tragedy and spoke of the changeable nature of events:

> *Evening crowned the city with peace and plenty, and general contentment—night brought the loud alarm—midnight saw its habitations enveloped in devouring flames—morning found these habitations empty and deserted—and noon presented to the saddened spectator a city of blackened walls and smoking ruins.*
>
> *Such is earthly property. To-day it is ours, to-morrow it is gone. To-day we enjoy it, to-morrow it is the source of another's pleasure. To-day we look upon it with pride, to-morrow our eyes closed in death. Behold the fashion of this world passeth away. It is even as a vapour, which soon vanishes. It is like the unresting tide, ever changing place.*

Like an ancient oracle, Reverend Smyth intoned Charleston's fate:

> *One woe is past, and behold another woe followeth hard after.*

AN IMPROVED DEPARTMENT AND THE FIRE OF 1849

E leven years would pass before the stench of death and destruction again assailed the senses of Charleston. The intervening period had brought enough attention to bear on the matter of firefighting that certain improvements were made. City engines, still supervised by whites but manned by slaves, were now stationed in each ward. New wells had been dug to increase the available water supply. Since the 1838 fire, several new volunteer companies had been formed.

In late 1838, the German Fire Company was chartered, eventually opening its firehouse on Chalmers Street in 1851. In 1839, the Marion Fire Company formed, followed by the Palmetto Fire Engine Company, which incorporated in 1841. Palmetto moved into a firehouse at 27 Anson Street in 1850. Both the German and the Palmetto houses were designed by the noted Charleston architect Edward C. Jones. The Hope Fire Engine Company joined the other volunteers in 1842. The Washington Fire Company was organized in 1849, a year marked by revolt and incineration.

On May 7, 1849, the Charleston Board of Fire Masters published an abstract of the "Regulations for the Government of the Fire Department." This document provided an in-depth look at exactly what constituted the "Charleston Fire Department" in 1849:

> *On an occurrence of a fire, the Chief Superintendent, or fire Master acting as such, to repair to a conspicuous spot in the vicinity which will always be designated by the Superintendent's Lantern at Night, and by the Engineers Red Flag in Day. All Fire Masters, Managers and Assistants of Engines, Leaders of Fire Companies, immediately upon their arrival to report themselves to him.*

*Managers of Engines when stationed, only to obey the Fire Master assigned to that post.

*The Superintendent of Engines to have under his charge the Engine Houses, Fire Engines, Hydraulics and Hose belonging to the city, all carriages, tools, apparatus, &c. connected therewith.

*That it shall be the duty of the Superintendent of Engines to attend the chief or acting Superintendent of the fire Masters at all fires, and to keep an account of engines, and the Leaders of the fire companies reporting themselves to the chief or acting Superintendent, and to make out a return of the persons so reporting themselves, and of the defaulters, which he shall deliver the day succeeding every fire, to the officer acting as Clerk, to be laid before the Board of fire Masters at their next meeting in order that such fines may be imposed as Council or the Board of Fire Masters may from time to time affix and direct, and to examine from time to time the several engines, and make all practicable repairs on the spot.

*The Clerk to have an office, in which he shall attend two hours of every day to receive communications, and give all information that may be required, and to have under his charge all buckets, hooks, ladders, and ropes, which he shall collect after every fire, and have deposited in their proper places.

There followed a list of various committees in place to further the interests of the fire masters:

The Committee on Engines, Wm. Lebby, Chairman.
The Committee on Combustibles, James Macbeth, Chairman.
The Committee on Accounts, James M. Wilson, Chairman.
The Committee to Examine into the Causes of Fires, A.J. White, Chairman.
The Committee to Examine City Engines &.c at Quarterly Examinations, the Whole Board.

The city was divided into four political wards, or precincts. Each had a number of public pumps from which the engines could access water. To ensure proper maintenance of these vital water sources, Charleston was divided into a southern division and a northern division, each with an engineer in charge of the pumps in his district.

John B. Martin managed the southern peninsula from a shop at the corner of Gillon and East Bay Streets, while E.M. Mood supervised the

upper peninsula from his shop at the foot of Hassell Street. The wards also functioned as geographic subdivisions within which the city's firefighting equipment was distributed.

The use of a segregated labor force had been debated throughout the 1840s. Some favored the use of only free men of color while others were of the opinion that only slaves with the requisite permission from their owners should be involved in firefighting. Though the motivation and overall effect of such labor was called into question time and time again, the segregation standard of the day would not have the menial work done by white men of any persuasion.

The dispersion of the engines and the firefighting tools made them available throughout the city:

> *Ward Engine Number One was located at the corner of Meeting and Broad Streets, in a firehouse behind the Central Guard Station on the southwest corner.*
>
> *The firehouse for Ward Engine Number Two was on King Street, near Tradd.*
>
> *Ward Engine Number Three was housed on Pinckney Street.*
>
> *Ward Engine Number Four was located on the Poor House lot.*
>
> *The firehouse for Engine Number Five was situated at the corner of Rutledge and Beaufain Streets.*
>
> *Two box engines, the most primitive of hand pump engines, were located on the lot of the Charleston Orphan House.*
>
> *One box engine was located on the lot of St. Phillip's Church.*
>
> *A firehouse on Queen near King held 2,300 feet of city hose, an elevating ladder, ladders, hooks and ropes.*
>
> *Hooks, ladders and ropes were stored in the stalls of the East Vegetable Market.*

To further the public's knowledge of the fire master's plan, the fire masters also listed the locations of more than a dozen wells:

> *Large Fire Wells, designated by a lamp painted red and lettered Fire Well, with a chain attached to foot of Lamp post and connected with the plug of Wells, located at the following street corners:*

Beaufain and Archdale	*Bull and Coming*
Liberty and St Phillip	*Church near Water*
Clifford and King	*Meeting near Market*

CHARLESTON IS BURNING!

Queen and Friend
King and Tradd
State and Cumberland
Minority & Wall
Burn's Lane and King

Meeting and Queen
George and Meeting
Tradd and Legare
King and Lamboll
Pinckney and Anson

Having so informed the general public, the clerk for the fire masters went on to close the document with a reiteration of the city ordinance that protected the equipment:

> *CAUTION: If any person shall willfully or carelessly break, injure, destroy, carry away or put to his or her own use any fire buckets, hook, ladders, ropes &c belonging to the city, used in prevention and extinguishment of fires, with "City" thereon, every person so offending shall forfeit and pay a sum not exceeding twenty dollars.*

The very day after the *Courier* published the description of the fire department and its plan, the *Mercury* reported a fire in Charleston's Neck, above Boundary Street, the second for that area in a month:

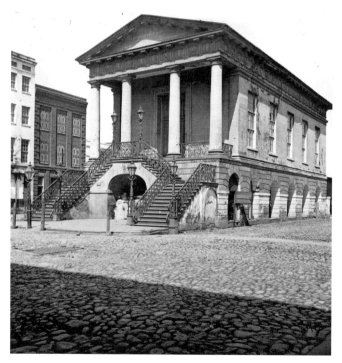

Situated right in the middle of a part of Charleston that was repeatedly burned over time, Market Hall has stood since 1841 as a grand sentinel, welcoming locals and guests to partake of the various commodities offered for sale in the market. *Library of Congress.*

Two Centuries of Fire and Flames

About 4 o'clock yesterday morning a workshop in the centre of the block bounded by Meeting, Henrietta, Elizabeth and Boundary streets, and owned by a colored man named Weston, was discovered to be on fire. From the highly combustible character of the adjacent buildings, being mostly old wooden structures, and the great scarcity of water, the flames spread rapidly, until all the houses on the block west of the line of the fire some three weeks since, were destroyed, except the grocery store on the corner of Meeting and Boundary Streets. The fire then crossed Henrietta Street about two hundred feet east of Meeting street, and penetrated through Charlotte street, on the south side of which it destroyed all the buildings to Elizabeth street. Two or three small buildings on the east side of Elizabeth street were also consumed by the fire, or pulled down by the firemen in their efforts to stay its further progress, which happily proved successful. Altogether, perhaps, there were between sixty and seventy houses destroyed, a large portion of which were comparatively of little value, and were inhabited by colored persons, and the loss may fairly be estimated at between thirty and forty thousand dollars... The firemen never displayed more energy, but for a long time, owing to the great scarcity of water, the fire retained the mastery.

There was no fire well in the Neck, perhaps due to the large black population or because the great fires had all occurred south of Boundary. The *Mercury* went on to call attention to the threat such a fire posed to the entire city, while also following the current line of thinking on the origin of the fire:

There is scarcely any reason to doubt that this wide-spread conflagration, which endangered the safety of the entire city, was the act of incendiaries, and the most active efforts are making for their discovery, the Commissioners of Cross Roads having with praiseworthy promptitude, offered a reward of five hundred dollars for their detection. We learn that a negro fellow was yesterday arrested on the charge of having attempted to fire the dwelling of Mr. Joseph A. Enslow, on the Neck. After an examination, in which he was detected in several falsehoods, he was committed for a further hearing.

The Second Presbyterian Church was for a moment in great danger, but firemen were able to get a hose to the roof and extinguish the flaming shingles. Whether Mr. Weston was careless with a candle or match or whether his property was deliberately burned is not known. The popular sentiment had conjured the image of a black insurrectionist, running through the night with a flaming torch in his hand. On July 13, 1849, several riotous

CHARLESTON IS BURNING!

black inmates of the workhouse on Magazine Street escaped, adding to the fevered pitch of anxiety among Charleston's white population. A day or two later, the *Courier* reported on another fire:

> *The alarm of fire yesterday was occasioned by the falling of a lighted Segar on the roof of an old shed in the rear of a building on Legare Street. The roof was old and highly combustible for the long drought, and the wind blowing freshly fanned the segar until the shingles became ignited and endangered the surrounding property.*

By the spring of 1850, the Great Nullifier, John C. Calhoun, was dead. The voice of states' rights was quieted, but the flames of Southern independence would spread throughout the decade. So, too, would the flames of destruction. On May 29, an editorial in the *Mercury* put the issue this way:

> *For the sacred purpose of self-protection, it is not only the right, but the duty of the South, to put forth its extreemest powers under the Constitution, if that much be necessary, and to throw itself in the way of the movement of the Federal Government, when its course tends to the establishment of a ruinous sectional victory over the principles of justice and equality on which the Union was founded.*

The May 8, 1849 fire began deep in the oldest portion of the city, but no attempt was made to insert the work of an arsonist as an explanation. The Charleston Neck, with its deteriorated conditions and large enclave of blacks, seemed a more likely place for such felonious conduct. In November 1849, Mr. Ross Sprigg was elected master of a new workhouse situated in the Neck. He proudly published a notice in the *Mercury* that apprised readers of the services to be provided and the necessary fees:

> *The Charleston Neck Work House...situated in the upper part of King Street, Charleston Neck, in the immediate neighborhood of the South Carolina Railroad Depository, it is now open for the reception of Negroes, for solitary confinement, safekeeping or punishment. A treadmill is now erecting and in the course of a*

few weeks will be in operation. Persons bringing Negroes from the country on the Railroad, or from other states, to be forwarded on the Railroad, will find this Institution very convenient from its nearness of location to the Railroad Depository. The Charges for gangs of Negroes will be moderate, and a liberal discount from the charges for a single Negro. The subscriber pledges himself to spare no pains in endeavoring to give the fullest satisfaction to all who may favor the Institution with patronage. The following are the charges for a single Negro:

> *Receiving—15 cents*
> *Discharging—15 cents*
> *Diet per day—15 cents*
> *Punishment—25 cents*

With two workhouses to dole out punishment to incorrigible slaves and a well-organized fire department, Charleston entered the "Decade of Disunion" confident that arsonists could be suppressed. Fires were the work of the devil, played out through the hands of the slave. White firemen would stomp out the fire and the devil with it. Political agendas displaced local issues as tavern talk turned to the rising sentiment of abolition. Slavery had been the way of the South since the beginning of the early colonies. Charleston was at the very forefront of the slave trade and benefited from everything that slavery offered. Incendiaries could be caught and punished; insurrectionists could be hanged. Abolitionists were a much greater threat: they demanded the complete destruction of the social order of the South, and they, too, were willing to die for their cause.

DISUNION AND DESTRUCTION

On the morning of May 29, 1850, a fire bellowed from Hayne Street near the market. The *Courier*'s narrative began with a recollection of a not-so-distant past. The Charleston Hotel, recently rebuilt in the same splendor that had graced its predecessor, was again about to be engulfed:

> *It is only a short time since that we were called upon to chronicle the losses of one disastrous conflagration, when it becomes our painful duty to note those of another, involving the destruction of property variously estimated from three hundred and fifty to four hundred thousand dollars, and that too as there is every reason to believe, by the hand of an incendiary. Between 2 and 3 o'clock yesterday morning St. Michael's bells sounded the alarm of fire, which was found to proceed from the rear of the premises occupied by Messrs. F.D. Fanning and Co. on Hayne Street, which spread with astonishing rapidity and in a short time this tenement together with those adjoining to the East and West were in flames, and as they spread, this valuable block of buildings, together with the Charleston Hotel, which seemed destined to inevitable destruction, were objects of deep solicitude among all classes of our citizens, and never have we seen such efforts put forth to arrest the progress of this terrible element, as were displayed by the fire department...*
>
> *The Hotel was for some time in imminent danger from the burning buildings on Hayne Street. The wind was blowing lightly from the South-West, and the flames were blown across the street, until they lapped and kissed the almost entire South side of the building, burning the window frames and shutters, and some of the floors in the basement. But there were strong stout hearts within the enclosure, that seemed to say, so far shalt thou*

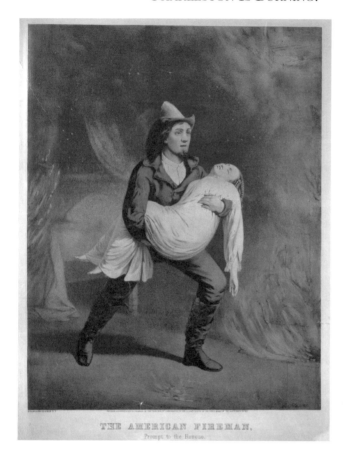

THE AMERICAN FIREMAN,
Prompt to the Rescue.

Heroism was a virtue second to none in the life of a volunteer fireman. Buildings could burn, but human life must be saved. This iconic image portrays not just the reality but also the romantic image of a fireman. *Library of Congress.*

go and no farther. Those attached to the establishment, with the aid of some of our citizens, were manfully at work inside, in carrying water, and using it judiciously, while a force from the Rail Road, under the direction of Messrs. Collum and McMillan, who, having reported themselves for duty, were stationed on the roof of the building, and did good service. Their united efforts, and a fortunate change in wind direction, saved this noble structure from destruction...the Market Hall at one time was in imminent danger, but happily it did not take fire.

The next day, the *Courier* went on to praise the work of firefighters, while telling an interesting tale about the start of the fire:

In so extensive and protracted a scene of devastation, the zeal, energy and efficiency of our indomitable firemen had ample opportunity to display, and

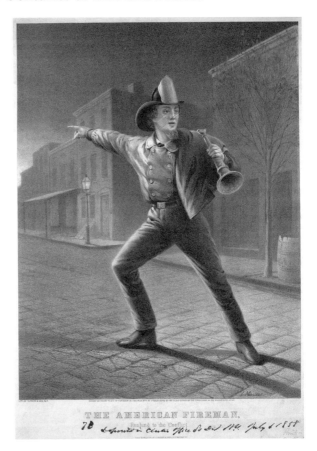

THE AMERICAN FIREMAN,
Rushing to the Conflict

Though somewhat romanticized, this portrait of a volunteer fireman served to inspire confidence and attract newcomers to the ranks. Widely circulated in print, such images served as enlistment posters, advertising the challenge of firefighting. *Library of Congress.*

never were they more strikingly exhibited. Many of our citizens also were conspicuous in their noble efforts to preserve and protect property of their fellow citizens. It is gratifying to state so far we were able to ascertain, that no accidents occurred, though life and limb were freely and frequently hazarded.

From the manner of its origin, there is every reason to believe that this disastrous fire was the work of an incendiary, as there had been neither fire nor lights used on the premises for several weeks past. Mr. Francis Miller, who occupied a room over the store of Mr. Waldron, and had returned from a party a little before two o'clock, distinctly heard the sound as of some person leaping from the fence, and he had retired to rest but a few minutes when the alarm sounded. There is but too much reason to believe in the existence of a band of these miscreants in our community, and we trust that efficient measures may be taken for their detection, and if apprehended that no mistaken notions of mercy may interpose between the offenders and the most rigid penalties of the law.

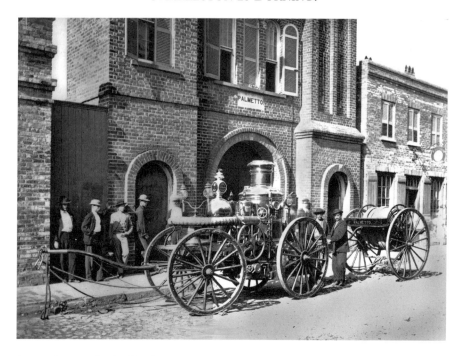

A rare photograph of a Charleston volunteer company and its fire engine. Pictured here is the Palmetto Fire Company at 27 Anson Street. *Historic Charleston Foundation.*

By 1850, Charleston had expanded up the Neck with a population of more than forty thousand persons. The Neck accommodated those people who, for socioeconomic and/or racial reasons, could not live on the southern side of Boundary, which is now Calhoun Street. Calhoun became a demarcation line of sorts, with the old families of Charleston comfortably entrenched on the peninsula's southern tip.

In April 1852, political talk turned to action as twenty-one men were appointed to a committee to prepare South Carolina for a states' rights convention. Harriet Beecher Stowe's *Uncle Tom's Cabin* had been recently published, providing a lightning rod for public opinion on slavery. The polarizing effect of Stowe's work was incredible, as it brought a very sharp point to bear on the cruelty and suffering of African slaves.

The city became a hub for commercial production and rail transportation. The mills, foundries and factories manufactured a variety of goods but dramatically increased the chances of accidental fires as well. Pushed to the outer fringe of the city, Charleston sought to protect the core of its residential area from such a threat. Blind and sash factories proliferated on both the western and eastern sides of the peninsula, with one such company situating

its business near Hassell and East Bay. In only a few years, the wisdom of placing such production facilities anywhere near populated areas would be severely challenged.

On April 13, the fire alarms were sounded, and firemen rushed to extinguish a fire in a wooden building at the southeast corner of King Street and Burns Lane. The grocery was a total loss, and as the fire jumped to the west side of King Street, it consumed four more houses and another store. Water damage ruined many of the goods in a store on the northeast corner opposite the fire, where Mr. Habersham did business.

Christmastime 1852 was marred by yet another tragedy just one block from the April fire. Early on the morning of December 24, a store owned by Mr. Valentine Heidt and situated at the corner of King and George Streets was totally consumed. Several firemen were injured fighting an inferno that began with one man's carelessness. The *Courier*'s story of the fire painted a picture of chaos and tragedy, but it also provided a cautionary tale to the reader:

> *About daylight yesterday morning a fire broke out…corner of King and George Street…the American Hotel, directly opposite, was in imminent danger, but was saved by the energies and well directed efforts of the Firemen.*
>
> *During the fire an accident occurred resulting in severe if not fatal injury to some of our most active firemen, and which has called forth the warmest sympathies of our community for the unfortunate sufferers. While Messrs Thomas W. Daggett, Robert Forsyth, Alexander McKenzie and Wm. Claggett of the Charleston Fire Company, and Messrs. Wm. Smith and G.W. Horton, of the Palmetto, were stationed on the portable Fire Ladder, which is about forty feet high, directing streams of water on the burning building, an attempt was made to change its position, and it was overturned, precipitating these gentlemen to the earth with terrific violence.*
>
> *Mr. Daggett, who was at the top, was thrown across the telegraph wires, which broke the force of the fall, but he received painful injuries on his head and back. Mr. Smith fell on the branchpipe, which penetrated his side, inflicting a most painful and dangerous wound. Mr. Forsyth had the back part of this skull badly fractured, and lies in a most precarious situation, with but slight hopes of his recovery. Mr. Claggett had his knee sprained and much bruised, and Messrs. McKenzie and Horton escaped with but slight injuries. Medical attendance was prompt at hand, and all was done that could possibly mitigate the sufferings of these unfortunate gentlemen, and their wounds being dressed, they were severally conveyed to their homes.*

RETURN OF FIRE *Corner King & George sts Dec 24th* 1852

	NAMES OF COMPANIES.	HOURS.		PREMIUM.		TOTAL AMOUNT.
1.	EAGLE FIRE-ENGINE COMPANY,	2½				$ 40
2.	VIGILANT " "	—				
3.	PHŒNIX " "	2½				40.
4.	CHARLESTON " "	"				40.
5.	ÆTNA " "	"				40.
6.	MARION " "	"				40.
7.	GERMAN " "	"				40.
8.	PALMETTO " "	"				40.
9.	HOPE " "	"		$25 –		65
10.	WASHINGTON " "	"				40
						$385.00

CITY APPARATUS.

CITY ENGINES.	MANAGERS.	HANDS.	PREMIUM.		HOURS.		TOTAL AM'TS.
CITY ENGINE No. 1,	2	30			2½		$ 21.25
" " " 2,	3	10			2		8.00
" " " 3,	2	30			12¼		104.13
" " " 4,		*no return*					
" " " 5,	3	30			6		54.00
" " " 6,	3	28			6		51.00
" " " 7,	3	30			2½		22.50
" " " 8,	3	30			2½		22.50
" " " 9,	3	30			2½		22.50
ELEVATING LADDER,							
TRUCK,	2	13			2½		11.87
HOSE CARRIAGE,							$

Engine No. 3 30 ... station duty ... 12½ $112.50
No. 4. allowed her pay at meeting of the .. Totals $430.25
Board 16th July.
3 Managers 30 hands Prem $15 + 12¼ hrs ... $ 125.13
Elevating Ladder allowed her pay at meeting of Board 16 July.
2 Manrs 15 hands ... 2½ hrs ... $ 11.87

The actual fire ledger representing the fire on December 24, 1852. Note the names of volunteer companies responding and lengths of time attending to the fire. *Special Collections, Charleston County Library.*

Two Centuries of Fire and Flames

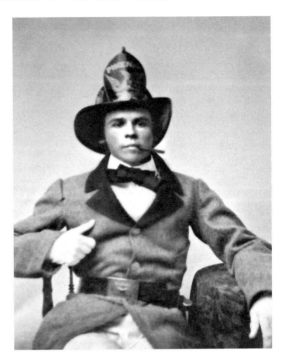

Youthful but proud, a young William Augustus Boyle profiles the character of the volunteer fireman. Public service with the Phoenix Fire Company was only the beginning of a career that included serving with the Palmetto Guards on Morris Island during the opening bombardment of the Civil War. After the conflict, Boyle went on to be a successful railroad man and was later appointed chief of police in the early twentieth century. *Boyle Family Collection.*

We are informed that the fire was occasioned by the flame of a candle, coming in contact with the vapor of spirit gas, while it was being poured from the measure, into a tin can. We mention this for purposes of the investigation which, we understand will be held this morning, as we deem it of the highest importance that occurrences involving the destruction of large amounts of property, and frequently of life itself, should be rigidly inquired into, and the results laid before the community for their information and benefit.

Volunteers from different and competing companies, each proudly representing his unit, were injured while working together to put out the flames. Though competition for the city-paid premium was keen, not everyone could arrive first at the fire. Those arriving later stood by and were directed by the fire masters to either assist the other units or to remove themselves from the scene. Though no official records suggest anything other than good-natured jockeying for "first on scene," such was not the case in other cities.

The April 26, 1852, issue of the *New York Times* carried the story of competing firemen creating mayhem on the way from a fire scene:

RETURN OF FIRE *Cooks Store King & May Feby 20th 1853*.

	NAMES OF COMPANIES.	HOURS.	PREMIUM.	TOTAL AMOUNT.
1.	EAGLE FIRE-ENGINE COMPANY,	3		$ 48.
2.	VIGILANT " "			
3.	PHŒNIX " "	2¾		44.
4.	CHARLESTON " "	2¾		44.
5.	ÆTNA " "	2¾		44.
6.	MARION " "	3	$25.-	73.
7.	GERMAN " "	2¾		44.
8.	PALMETTO " "	2¾		44.
9.	HOPE " "	2¾		44.
10.	WASHINGTON " "	3		48.
				$433.00

CITY APPARATUS.

CITY ENGINES.	MANAGERS.	HANDS.	PREMIUM.	HOURS.	TOTAL AM'TS.
CITY ENGINE No. 1,	3	30		2¾	$ 24.75
" " " 2,	3	30		13¾	123.75
" " " 3,	3	30		7¾	69.75
" " " 4,	3	30		6¼	56.25
" " " 5,	3	30		6¼	56.25
" " " 6,	3	30		3	27.00
" " " 7,	3	30		3	27.00
" " " 8,	3	30	$15.-	15¾	156.75
" " " 9,	3	30		7¾	69.75
ELEVATING LADDER,					
TRUCK,	*return incorrect (returned for correction)*				
HOSE CARRIAGE,					$611.25

Truck for this fire - 15 hands - 3 hours - $11.25

This page and next: Fire department records of the fires of February 20, 1853, and April 18, 1854. *Special Collections, Charleston County Library.*

RETURN OF FIRE *Hayne St April 18th — 1854*

	NAMES OF COMPANIES.			HOURS.		PREMIUM.	TOTAL AMOUNT.
1.	EAGLE FIRE-ENGINE COMPANY,			*Gratis 2 alarm* 9—1 =10 hours			$160 —
2.	VIGILANT	"	"				
3.	PHŒNIX	"	"	8½=1=9½ "	25.00 *2 alarm*	177. —	
4.	CHARLESTON	"	"	8½=1=9½ "		152. —	
5.	ÆTNA	"	"	8½=1=9½ "	25.00 *1 alarm*	177. —	
6.	MARION	"	"	9=1=10 "		160.	
7.	GERMAN	"	"	10½=1=11½ "		184.	
8.	PALMETTO	"	"	9=1=10 "		160	
9.	HOPE	"	"	9=1=10 "		160 —	
10.	WASHINGTON	"	"	9=1=10 "		160 —	
							$1490 —

CITY APPARATUS.

CITY ENGINES.		MANAGERS.		HANDS.		PREMIUM.		HOURS.		TOTAL AM'TS.	
CITY ENGINE No.	1,	3		20		$15		9		96	00
" " "	2,	3		"				"		81	
" " "	3,	2		"				"		76	50
" " "	4,	3		"				"		81	00
" " "	5,	2		"				"		76	50
" " "	6,	2		"				"		76	50
" " "	7,	3		"				"		81	—
" " "	8,	3		"				"		81	—
" " "	9,	3		28				"		76	50
ELEVATING LADDER,		3		30				"		81	—
TRUCK,		1		9				"		27	—
HOSE CARRIAGE,								17½		26	25

Manager Braun No 3. 15¼ hour in all — . — . — . 7.63
" Lafar No 6. 7½ " " " — . — . 3.75
$871.63

Philadelphia, Sunday, April 25ᵗʰ: A stable on the corner of Twelfth and Lombard streets was destroyed by fire this morning at one o'clock. Two horses perished in the flames. When returning from the fire, the Sniffler Hose Company was attacked at the corner of Eighth and Lombard streets, by a gang of rowdies belonging to another company. Missiles were fired among them, and police officers Walton and Jones were hit and severely injured. They returned the attack by firing their revolvers upon the rowdies. One of them, James Gillespie, belonging to the Moyamensing Hose Company, was hit in the back by a ball, and mortally wounded. The officers gave themselves up to await an investigation.

On February 20, 1853, fire struck again, but this time the destruction was located farther up into the Neck near Mary Street. Once again, the heroic escapades of the volunteers earned high praise. The *Courier* detailed the event:

About three o'clock, yesterday morning, the large frame building at the northeast corner of King and Mary Streets, owned and occupied by Mr. J.A. Cook as a grocery store was discovered to be on fire, and in a very short time the building and contents were completely wrapped in flames. The ignition of some explosive matter blew out the front and side of the store, into the street, and the frame building on the opposite corner, occupied by Dr. Hummell, as a drug store, took fire, and was rapidly consumed…the livery stables of Mr. Rabe, were in imminent danger, and had they once taken fire, nothing could have prevented its extension to the Cotton Yard of the South Carolina Railroad…and the inevitable destruction of many thousands dollars' worth of property. This was happily prevented, however, by the persevering and well directed efforts of the firemen…

A good many articles of furniture were carried off by miscreants, who are ever ready to avail themselves of such opportunities to plunder. Some of these were recovered yesterday by the police, and we hope the marauders will be summarily dealt with. The efforts and daring of the firemen were beyond all praise. Notwithstanding repeated explosions of gunpowder and camphene, they fearlessly struggled with the flames in the most exposed situations.

On April 18, 1854, the *Charleston Courier* reported another fire that sprang from a combination of chemicals and mercantile goods. This time, the drugstore of Dr. P.M. Cohen on Hayne Street and the drug establishment of Haviland, Harral & Co. were destroyed. Also burned were a hat store, a shoe

store, three dry goods dealers and a sadlery dealer. The fire also brought another close call for Charleston's finest hotel:

> *The Charleston Hotel had a narrow escape from being consumed. Mr. Mixer, however, boldly met the danger and with the aid of the Fire Department, his boarders and guests, officers of the establishment and domestics, so successfully combated the devouring element that the building was uninjured.*

On October 30, another blaze destroyed a carriage maker, Gilbert's Carriage Factory. In these last three fires, the highly combustible materials found in an apothecary, together with the flammable goods found in various

The response of the volunteer companies is recorded from the fire of October 31, 1854. *Special Collections, Charleston County Library.*

stores, provided ample fuel for a giant disaster, but in each case the destruction was limited to only a few adjoining buildings. Based on the praise and thanks bestowed on the volunteers, it appeared to the daily newspaper reader that they had learned their trade well.

By 1854, the ranks of each fire company were filled with men beaming with enthusiasm and pride. This exuberance extended to parades and other festive events, which gave each company a chance to show off to the people of Charleston, with volunteers regaled in their finest uniforms. Brass buttons, brass trumpets and bold colors reflected the spirit of each unit as it marched in step to the accompanying musicians.

Few could know that the merriment of the moment was a prelude to a grim time in American history. In the same issue that covered the fire at the carriage works, the *Courier* printed a lengthy editorial that asserted the philosophical and practical arguments for slavery that were prevalent throughout the South. Talk of disunion and secession was common. The feature began by extolling what was held by most white people to be a benevolent gesture in bringing the Africans to America:

> *The slave trade then has been a blessing both to Africa and America. Why may it not still go on civilizing the savage, and developing the resources of a splendid region? Why should the law of nations, under the plea of humanity, affix the severest penalties and the blackest stigma to a traffic which has accomplished so much in behalf of humanity?*
>
> *Thus the influence of the South in the Government…is constantly falling off, and in a few more years, the checks which she now exercises, being swept away, her fate, so far as Congress is concerned, will hang upon a single vote…thus imperiled, thus hunted down, thus struggling for life, against fearful odds, there is one obvious resource for the South. Whether she remains in the Union, or at last, goaded by wrongs and exactions, plants her foot on the rock of separated independence, in either alternative, there remains the same necessity…she must press onward with her institutions and civilization. Slavery must spread in area and power. The preponderating power of the Free States, ever on the increase, must be counterbalanced by the addition of Slave States. If the North colonizes for Abolition, the South must colonize for Slavery. The means of defense must multiply with the means of attack.*

By 1855, Charleston's economy was waning, while the number of immigrants, many of them Irish escaping the famine, continued to swell. Back alley shacks and shanties bulged with a humanity for whom work was

scarce and life's necessities elusive. Petty crime, especially prostitution, began to spread, along with bootlegging and gambling.

Police filled the district jail with men and women trying desperately to make quick money. Slaves, not immune to the influence of the newly arrived haranguers, found themselves in the workhouse next to the jail, flogged and smitten for allowing a "paddy" to lure them into games of chance.

The destruction of buildings was just one facet of a fire's wrath. Injuries received during a fire ranged from broken bones to burned skin. Aboard ships, sailors could be scalded by steam and hot water during an explosion. The practice of medicine in the mid-nineteenth century was not yet "modern." Any new revelation on the treatment of injuries or disease was of great interest to the newspaper reader. On February 20, 1850, the *Charleston Mercury* printed a portion of a paper from the *American Journal of the Medical Sciences*. The author of the paper, Dr. D.M. Reese, was a resident physician at Bellevue Hospital:

> *Among the most numerous cases brought into the surgical wards of charity hospitals, everywhere, may be reckoned the injuries received by burns and scalds, which when extensive, are too often fatal. In the treatment of these injuries we have had great experience and uniform success, when the patients were brought in soon after the injury…the universal treatment of all such cases is to cover the parts with weaten flour, thrown over the wounds by a dredging box, which if thoroughly done so as to exclude the air, and prevent its temperature from reaching the suffering tissues, will afford instant relief for the pain, and allay all that nervous irritation which is the chief source of immediate danger in all cases of extensive burns. We have had the opportunity to test this practice in terrible burns…in examples of persons while drunk falling into the fire, and others in which the clothes were burnt off the body by the combustion…the external application of the flour was in the first instance our only remedy, and this was continued for one or more days…the superficial portions of the burns or scalds would often heal under this application alone, and the solutions of continuity,*

more or less deep, which remained open and discharging, were then dressed with lime water and oil, by means of a feather, to which creosote was added if the granulations were slow, or the sloughs tardy in becoming loose.

Under this dressing the most formidable burns have been healed, and even when the face has been involved, there has been scarcely any considerable deformity…if this simple remedy were resorted to…there can be little doubt that the fatality of such burns would be very rare, while the popular and mischievous methods of applying raw cotton oil, molasses, salt, alchohol [sic], spirits of turpentine, sugar of lead water, ice &c. to extensive and deep burns, are, all of them, injurious and often destructive to life.

THE CIVIL WAR AND THE ADVENT OF THE STEAM FIRE ENGINE

By 1860, Charleston had become a city strained by internal and external factors. Beyond South Carolina, the argument for union was losing ground to strong sentiments for outright rebellion. The people of Charleston for the most part were not affluent; only a small number of Charlestonians held real wealth, whether in land, slaves or both. Ordinary white men enjoyed the status of being "white," despite their material poverty. A general outcry bemoaned the fact that the Irish would take work "not fit for a slave," thus upsetting the racially arranged social order.

Against this backdrop of social disorganization, the Democratic National Convention was held in Charleston in the spring of 1860. Soon the delegates were split along geographical lines, and the fractured attempt at party unity was disbanded. Subsequent efforts to heal the party and bring a united platform against the strength of Abraham Lincoln and the Republicans failed, and Lincoln ascended to the presidency. Every Southerner now feared that the North would stop at nothing to abolish slavery.

By December 20, the Secession Convention convened in Charleston, strongly united by sectional sentiment. Vowing that the South and its "peculiar institution" must be preserved, the Ordinance of Secession was approved with a unanimous vote. Standing alone as the Republic of South Carolina, the state set about the work of building up its military resources.

The next decade was unlike any other that South Carolina had experienced. Charleston was on the ebb of a changing tide. The customs and traditions of the Old South now seemed precarious, but most agreed that they were worth fighting for.

In 1860, the burden of sorting out the fire department fell to Chief Moses Henry Nathan, a former Charleston businessman who had begun his career

Charged by an atmosphere of jubilation, the delegates to the Secession Convention voted South Carolina out of the Union on December 20, 1860. Four long years later, the cause of Southern independence would be reduced to a whisper on the lips of countless widows and orphans, who found nothing to cheer about. *Library of Congress*.

as a fireman in 1839. Nathan was elected chief in January 1859, giving him two whole years to organize the city department and the volunteer companies into a cohesive unit before hostilities began.

In February 1861 the Federal ship *Star of the West* was turned back by Citadel cadets whose gun batteries deprived the Yankees at Fort Sumter of much-needed supplies. Now, Charleston could only wait and watch as decisions were made far away that would seal the fate of a nation.

Despite a flurry of last-minute negotiations, Sumter refused to give up the key to control of Charleston Harbor. After a three-day bombardment, the fort surrendered to Confederate forces. Though the Union commander, Major Robert Anderson, had been brought to his knees, the government of Abraham Lincoln had been brought to full attention. The rebellion foretold for so many years was now a reality.

The Federal officers' quarters and other structures at Sumter caught fire during the shelling and could be seen burning both day and night. The location of the fire, removed from downtown Charleston and

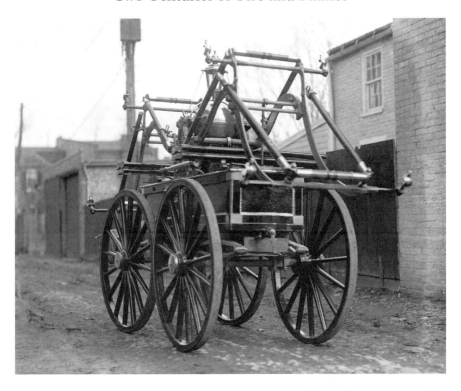

A typical hand-pump fire engine. Though popular from the eighteenth century onward, these machines were still used in the early twentieth century as well. Firemen sang songs to keep rhythm with the strokes, thus providing an even flow of water from the hose. *Library of Congress*.

surrounded by water, provided the fire department with an opportunity unlike any other.

Confederate general P.G.T. Beauregard sent Chief Nathan and his men to Fort Sumter to put out several fires both during and after the bombardment, a testimonial to the enduring bond between Beauregard and Major Anderson, who had instructed the Southern general at West Point.

After the Union surrender, Nathan returned, but this time he also took out the Charleston Fire Company of Axemen, along with its new steam engine. The apparatus proved to be a remarkable engine, but the firemen remained hesitant to use it beyond the isolation of Sumter. In other cities, such machines had blown up, taking the entire crew of attending firemen with it. To calm such fears among the Confederate soldiers now manning the fort, a hand pumper, City Engine Number 3, remained at the fort until 1862.

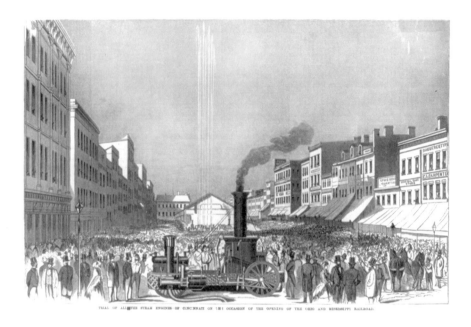

TRIAL OF ALL THE STEAM ENGINES OF CINCINNATI ON THE OCCASION OF THE OPENING OF THE OHIO AND MISSISSIPPI RAILROAD.

Hailed as a "smoking beheamoth," the early steam fire engines were admired but distrusted by firemen, who feared that the super-heated boiler would explode, hurling the men into the very flames that they were trying to put out. Numerous engines did burst at the seams until better methods were devised to regulate the control of pressure. *Library of Congress.*

War would soon deplete Nathan's source of manpower. Arguing to keep the fire companies together, the firemen were eventually exempted from military duty after Nathan lobbied city council. Still, most volunteered to fight for the new Southern republic. For the fire volunteers, the regimentation of each company proved to be an excellent training ground for disciplined military recruits. Chief Nathan noted in his reports of May 1861 that three hundred firemen had enlisted in the cause of the Confederacy. Before the firing on Sumter, R.D. Bacot, president of the Phoenix Fire Engine company, had received a petition from his men dated January 1, 1861. It informed Bacot that the men had formed a militia unit, the Phoenix Rifles. A document that followed listed in detail the proposed uniform for the soldiers, including "a coat similar to the present Phoenix coat but with standing collar…and white palmetto buttons."

As war progressed, the fire halls were emptied of men as other militias formed along the lines of their respective fire companies. In their stead, few men remained who were physically capable of doing the work. Those volunteers who remained were joined by elderly men and individuals not fit for military service. Inevitably, the controversial topic of manning the

firehouses with free blacks and slaves was again debated. Only eight months into the conflict, the beleaguered fire department would face its greatest test, one that it would fail with great indignation.

The hand-pump fire engine had been the mainstay of firefighting since the eighteenth century. With a pair of handles on either side, the engine required teams of men working in unison to pump the water from the tank through the hoses and onto the fire. It was not uncommon to see the Charleston Fire Department deploying blacks to work the handles while the white volunteers played the water back and forth. The white city supervisors looked to the maintenance of the machine and kept an eye on those at the handles.

The exact method of pumping and spraying was described in a pamphlet published by the William Jeffers Company, one of several manufacturers of the hand engine. The technique depended on whether the handles were located on the sides or front and back:

Fill the tub, attach one section of hose and put the butt into the box, and practice the men fifteen seconds at a time, until they can make at the rate of 200 strokes per minute on a side stroke, and 130 on an end stroke...in playing through long hose, get up the stroke gradually, commence slow and increase until you get the strain upon the hose, but do not be so long about it as to tire the men before the test comes. The company should be sure to make each succeeding stroke a little quicker than the preceding one.

The most tedious job with the hand engine was keeping the tub full, a task that often took hundreds of volunteers who formed the bucket brigade from the well to the engine. Friendly competition between companies after a ceremony or parade offered the volunteers an opportunity to practice their aim, but the actual amount of water coming out of the hose was completely dependent on the exertion of the men at the handles.

PROVIDENCE AND THE GREAT FIRE OF 1861

By the fall of 1861, the North and the South were fully engaged in a conflict far more involved and much deadlier than anyone could have imagined. Though the Confederate forces had prevailed at the big battle outside of Washington, the Union was pressing the entire Southern region. The victory at Manassas provoked a tactical response from the Union that focused on controlling every one of the South's vital ports. On November 7, Port Royal, South Carolina, fell, giving the Federals a deep-water port from which to attack the entire Confederate coast. General Robert E. Lee came to Charleston during that time and joined General Roswell Ripley in reinforcing the coastal defense line against a pending Yankee advance.

During the evening of December 11, 1861, while rowing across the Ashley River to Charleston's west side, General Lee and his staff saw a fire reflected in the distance from the peninsula's east side. Unaware that the fire would grow into a raging mass of destruction, Lee continued on to the Mills House Hotel at the corner of Meeting and Queen Streets. Lee met his guests for dinner, not knowing that the pleasantness of the evening would be short-lived and that their very lives would soon be threatened.

Based on most accounts, the fire began at William P. Russell's Sash and Blind Factory, situated on the Cooper River at the foot of Hassell Street. The fire burned out of control until it had nothing else in its path to destroy. A path of demolition ranging from the northeast side to the southwest side of Charleston would for years be referred to as the "burnt district." An extract from the Schirmer family diary that was written as the fire began reads:

December 11ᵗʰ, Awful fire this evening about 9 o'c the alarm was given,
it proved to be the work shop of Mr. Russell on the wharf at the extreme

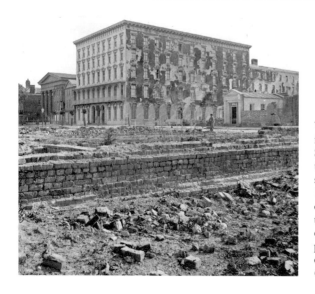

With flames threatening from directly across Queen Street, it is remarkable that the Mills House Hotel survived the Great Fire of 1861. Robert E. Lee was entertaining guests at the time of the fire and was evacuated along with his party to the Alston Home on High Battery. *Library of Congress.*

RETURN OF FIRE *Great Fire Decr 11 & 12. 1861*

Wards 1, 2, 3, 4.

	NAMES OF COMPANIES.	HOURS.	PREMIUM.	TOTAL AMOUNT.
1.	EAGLE FIRE-ENGINE COMPANY,	36		576
2.	VIGILANT *Steam Engine*	36		576
3.	PHENIX " "	36		576
4.	CHARLESTON " "	36	25	601
5.	ÆTNA " "	36		576
6.	MARION " "	36		576
7.	GERMAN " "	36		576
8.	PALMETTO " "	38		608
9.	HOPE " "	36		576
10.	WASHINGTON " "	36		576
				5847

CITY APPARATUS.

CITY ENGINES.	MANAGERS.	HANDS.	PREMIUM.	HOURS.	TOTAL AM'TS.
CITY ENGINE No. 1,	2 / 2	30 / 20	state.	17	402.50
" " " 2,	3 / 3	30 / 20		17	276.50
" " " 3,				17	
" " " 4,	2 / 2	30 / 20	16	17	417.50
" " " 5,	3 / 3	30 / 20		17	380.50
" " " 6,	3	30 / 20		17	380.50
" " " 7,	3	30 / 20		17	380.50
" " " 8,	3	30 / 20		17	380.50
" " " 9,	3 / 3	20 / 20		17	432.50
ELEVATING LADDER 10	3	30		17	276.50
TRUCK,	3	20			
HOSE CARRIAGE.					
					3527.50

The Great Fire of 1861 is forever memorialized in the official ledger of December 11, 1861. *Special Collections, Charleston County Library.*

end of Hassell St. The wind blew a perfect gale and it may be said to be a Hurricane of Fire. In less than 2 hours it was raging in Cumberland Street, it continued with increased fury until 12 o'c next day when it ceased for the want of fuel...sweeping everything before it until it reached Chisolm's causeway.

On December 13, the *Charleston Times* gave the news. This was the worst fire ever in terms of the number of significant structures lost. Churches and social halls fell in piles of brick and cinders. The Charleston peninsula was sliced by a diagonal line of absolute and total devastation:

The fearful conflagration that has just passed over our city will cause the 11th and 12th of December, 1861, hereafter, to be remembered as one of those dark and trying periods, which for the moment seems to paralyze all the long cherished hopes and bright anticipations of the future. We have been visited by one of those mysterious dispensations of Providence which we cannot attempt to solve.

Our city has received a terrible blow, which it will take the work of years to repair. Let us nerve ourselves then for another start, thankful that we are still left with the same bold spirit and strong arms to make new and, perhaps, more substantial prosperity for our beloved city.

As we apprehended at the time...the flames continued to increase in virulence, and with the scarcity of water, seemed to defy all human efforts to arrest them...roof after roof fell in, the fire rushed out of the windows and lapped around buildings, presenting an awfully sublime appearance.

...the fire rapidly extended to both sides of Broad Street, igniting several fine mansions near the corner of Logan and Mazyck Streets, and including that time-honored structure in Broad Street, St. Andrews Hall, which in a short time had nothing standing but the bare walls...having crossed the city from the Cooper to the Ashley, the flames seemed to make one last desperate struggle for existence...and then yielding to its fate, sending its dying hisses, as though scorning the powers that so gallantly resisted its progress. The loss of property has been variously estimated at from five to seven million dollars.

Five churches, namely: The Circular, the Cumberland Methodist Church, St. Peter's Church in Logan Street, St. John's and St. Finbar's Cathedral...and the Quaker Meeting House in King Street...St. Andrew's Hall, Institute Hall, the two Savings Institutions, the Theatre and large Southern Express buildings are all gone. The Mills House was only saved through almost superhuman exertions and its blackened walls attest the severe trial it had undergone...

It [the fire] *was first discovered issuing from the sash and blind manufactory of W.P. Russell and Co....Mr. Russell thinks it the work of an incendiary. The establishment had been closed and the furnace of the boiler covered with water before the men left. The proprietor did not leave for an hour and a half or more after the workmen. When he left everything was in order, and no sign of fire or anything approaching to it. In about an hour and a half afterwards Mr. Russell heard the alarm of fire, and learned that his establishment was on fire. From these circumstances he infers that the fire was set or was the result of carelessness on the part of a number of country negroes who had been quartered under an old shed adjoining the establishment, in allowing their camp fire to get ahead of them...the steam engine gave much satisfaction, and was particularly grateful relief to our men when exhausted.*

After sending one of his staff to the roof of the Mills House to reconnoiter, General Lee ordered his party to evacuate. The town home of the Alston family, situated on High Battery, was placed at their disposal, and though the family was not in town, their son was kind enough to make the arrangements.

Out of harm's way, Lee waited out the fire while General Ripley supervised the local troops and the hundreds of ordinary citizens who pitched in to

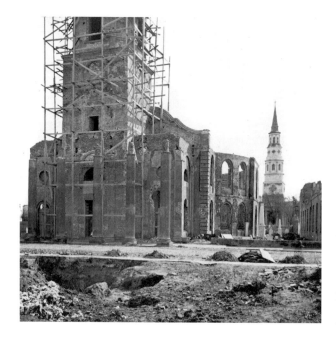

The Circular Congregational Church on Meeting Street is propped up to prevent total collapse after the 1861 fire. *Library of Congress.*

102

stem the flaming tide. Ordering the demolition of several houses on Queen Street, Ripley turned the flames away from Roper Hospital, the workhouse and the jail. Charges of dynamite left gaping blocks of brick rubble that gave the fire nothing from which to draw strength.

On December 19, 1861, the *Charleston Mercury* pointed to the causes of the fire's stubbornness:

> *The great want of the firemen was water; and when we remember that the wind was blowing a gale and the quick spread of the fire we wonder that more was not lost. The chief and his Assistants, as well as the several companies, exhausted themselves in their efforts to control the flames; the result proved that the elements were too strong for them. But for the great services they rendered, they deserve the warm thanks of the whole community.*

The sheer magnitude of the fire caused Charlestonians to record the event in great detail for relatives out of town and thus for posterity. More amazing than the account of the fire is the story of how a letter from a Charleston woman to her brother in Confederate service was finally delivered in June 1887! The baggage of Francis L. Frost was captured after the Battle of Antietam by Union forces under General George B. McClellan. Frost's clothing was "re-issued" to a young Union soldier who was described by his commanding officer as being "sans culottes." Colonel Thomas W. Egan, Fortieth New York Infantry, then ordered a member of his staff, John H.B. Jenkins, to examine the contents of Frost's valise. Jenkins wrote to Frost on June 4, 1887, to tell him of his find:

> *I enclose herewith a letter from your sister, Miss Lizzie Frost, dated December 14th, 1861, describing the great fire in Charleston during that month. This letter was in your valise…I found the enclosed letter and was so interested by the graphic description of the fire and the womanly affection pervading the letter that I got permission to keep it…I ascertained your continuance in this life from Mr. E. Prioleau Henderson, formerly of Hampton's Legion, now a clerk in this office and immediately determined to return the letter to you.*

Miss Frost's letter of December 14, 1861, was a dramatic and personal account of the fire's wrath:

> *My dear Frank…the fire commenced at 9 o'clock Wednesday night in the sash factory at the east end of Hazel Street—the wind was very high…it*

soon became apparent that the whole city was in danger. At an early hour the cinders were falling on our house, and at nine o'clock we began to watch our roof and were obliged to continue to do so until twelve the next morning. At 3 o'clock the fire had crossed King Street...and Papa thought it best to have us out of the house, we then packed our clothing and went to Mr. Kirkpatrick's on East Bay...

The house was very desolate, no furniture in it, and after a few minutes, Alice, Ann and myself became so restless that...we ran down to the Post office, where we saw that Broad Street was in flames, then becoming frightened we ran back to Mr. K's and got there in time to see the Cathedral spire burn and fall, it was a magnificent sight, all the intricate pieces of wood work were on fire and the cross shown brilliantly to the end...

At day dawn, Alice and myself mustered courage enough to go to see the ruins...in Friend Street, the flames were bursting through the windows of the houses back of Miss Pringles. We then went back to tell mama the news, but not expecting our house to stand very much longer, on the way we bought a loaf of bread expecting it to be all our breakfast, but Cousin Allen Lowndes sent us some hot tea and bread and beef and insisted on our going to her house which was comparatively safe...

The fire was so general and gentlemen so scarce and the carts by no means sufficient for the emergency which caused the loss of a great deal of furniture and other valuables. I feel so confused and excited that I cannot give you a collected account of everything...the fire is thought to have been the result of carelessness—the owner of the Sash factory I am told had received frequent warnings but to no purpose. A good many persons think it was helped by the negroes and some think by Yankee emissaries, but the fire took a very natural direction, following the course of the wind entirely—most of the negroes behaved admirably, our own servants and those of the neighborhood were untiring in their efforts to save everything, and to do all they could for us. Brother Tom says Gabriel displayed great bravery on Mrs. Turnbull's house—he was sent where none of the whites who were ordering him would have dared to, and at the last Brother Tom said he had to interfere and tell him not to go a step further than he felt he could do with safety.

With so many of the Charleston firemen away at war, the ranks in the firehouses were thin. The enormity of the fire brought together a band of heroes from all walks of life. Slaves joined freemen and white businessmen as the buckets traveled back and forth. Against the sing-song rhythms of the blacks at the hand pumpers, the firemen with the lone steam engine played

the hose back and forth on the flames, mindful that at any time the water could give out, and it soon did.

Chief Nathan's actual notes on the 1861 fire were destroyed during the Civil War, but around 1872 he wrote a somewhat abridged narrative of the events on December 11 and December 12. In describing the actual beginning of the fire at Russell's, Nathan provides details that may have been the result of years of speculation on his part, as no contemporary version of the events is as precise. It is also interesting to note that the accounts at the time gave General Ripley great praise for placing the dynamite in such a way that the west end of Queen Street was spared. Nathan dismissed those efforts as ineffective:

> *The Great fire of 1861 commenced about 8 o'clock p.m. 11th of December at the workshop of E.P. Russell...this fire was caused by the carelessness of the occupant allowing the debris from his upper floor to be carried to the lower floor near the furnace and not having a proper watchman on his premises. On several occasions previous the premises were on fire before and put out by the workmen at Cameron & Co. opposite. The fire would have been checked but the Palmetto Co. did not have hose enough to reach...*
>
> *At this fire General Ripley then in command ordered several houses blown up but no good was affected. The last building burned was the church on Logan Street. At this fire the Pioneer Steamer just finished was on duty and did some good, but so severe was the gale that water was of no use. I attribute the extent of the fire to the neglect of the police then having charge of the tidal drains. When they were needed in Meeting Street near Queen, there was no water in the same. The fire could have been checked at that time but for the want of water.*

In 1861, one of the volunteer companies, the Fire Company of Axemen, had renamed its unit the Pioneer Fire Engine Company. Its engine house on Queen Street was burned down in the fire. The tidal drains that emptied out into the harbor sat at low tide during the worst of the emergency, leaving no water for the engines to draw from. The wind rose to gale force, pushing the fire along and out of the control. Sheer numbers of slaves and citizens could not replace the skilled firemen who had joined the Confederate army.

Altogether, the firemen were defeated at every turn by one dilemma or another. December 13 found the fire department exhausted; the fire's victory was absolute. With so much of the city in ruins, the Yankees at Port Royal may have felt some measure of satisfaction. Only President Lincoln could have found any humor in the fact that the Ordinance of Secession that

brought South Carolina out of the Union was voted on at St. Andrew's Hall and signed into effect at Institute Hall, both of which were destroyed by the Great Fire of 1861.

In his sermon of December 15, Reverend W.B.W. Howe of St. Philip's Church sought comfort for his flock and all of the people of Charleston by drawing inspiration from the book of Job in the Old Testament:

The book of Job, my beloved brethren, is the book of divine Providence, and exhibits the method according to which the divine purposes manifest themselves in relation to men...What has God wrought or permitted to be wrought?

We could weep over the city. The heart aches as it thinks of the houseless poor, the destruction of mansions associated with the sacred past, the desolation of noble halls, the ruin of churches, and of the beautiful cathedral which filled you, by its fair proportions, with a pure delight every time you passed it. We say, with Jeremiah, as we wend our way through the desolated streets, and in view of so many homes now, alas! in ruins: "Mine eye runneth down with water for the destruction of the daughter of my people...it is of the Lord's mercies that we are not consumed because His compassions fail not."

And, therefore, here, amid the sorrows which encompass us all, and amid the losses of which so many families in this congregation are very largely partakers, I desire, my beloved brethren, as your mouthpiece, to acknowledge God's mercy in the midst of judgment, and to give Him thanks for the preservation of this His sacred edifice, and for sparing you from beholding, a second time, your "holy and beautiful house, where your fathers praised God, burned up with fire, and all your pleasant things laid waste..."

I am conscious of another circumstance, and one which has been present to all hearts, doubtless, which seems to make this calamity assume still graver proportions...coming at this particular time when we are threatened by an invasion from ruthless foes, and

when our every nerve and muscle was strained to make a gallant defense…when all the necessities and comforts of life were more than usually difficult to procure…when for weeks and months past we had been earnestly engaged in ministering to the sick and wounded soldiers…when in every family the ruling question with the oldest and the youngest seemed to be, What can I do for the good cause…

Oh, then at such a time of all others, for this destruction to be permitted to take place, appeared strange, yea passing strange, if God was indeed with us and upon our side…and so with us at present, we are being tried, not punished. God would prove what our faith is made of: whether it is a mere holiday-faith, which lasts only when the sun shines, and when all things are prosperous, or whether it is of that robust nature, which will endure a great fight of afflictions—which is the substance of things hoped for, and the evidence of things not seen…this is the very essence of the trial, to believe that God is with us when, to all appearances, He has deserted us.

PEACE ... AND DESOLATION

For the duration of the war, fires were a constant problem. Begun in the late summer of 1863, the Union bombardment of Charleston sent hundreds of shells cascading into the city. Explosions ignited flames that threatened to bring more devastation to a city already reduced to rubble. Chief Nathan's notes on the 1861 fire ended with an observation that gave the catastrophe a different perspective, one shared by Reverend Howe:

> *It would seem that the hand of Providence intended this misfortune, for had not the fire happened many lives would have been lost in the bombardment of the city by the cursed Yankees, for thousands of their shells fell harmlessly in the burnt district which otherwise would have fell into the houses but for the fire.*

Traveling through what had been the Confederate States of America after the war, a newspaperman from the North spoke with a Charleston fireman. John T. Trowbridge recalled his comments:

> *But few fires were set by shells. There were a good many fires, but they were mostly set by mischief makers. The object was to get us firemen down in the shelling range. There was a spite against us, because we were exempt from military duty.*

On February 18, 1865, exactly four years from the day that Jefferson Davis was inaugurated president of the Confederacy, Union soldiers occupied Charleston. Fires and explosions lit up the sky as stragglers sought refuge in the country. Armed men in blue watched as looters filled their sacks with what few provisions were left on store shelves. On February 24, the *Fayetteville*

CHARLESTON IS BURNING!

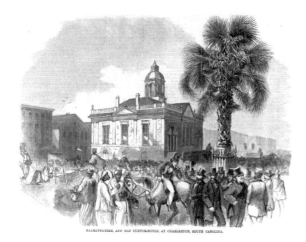

PALMETTO-TREE, AND OLD CUSTOM-HOUSE, AT CHARLESTON, SOUTH CAROLINA.

Near the intersection of Broad and East Bay Streets, the last Confederate defenders of the "Cradle of Secession" evacuated on February 17 and 18, 1865. Startled by Union general Sherman's march into inland South Carolina, the Southern troops took their leave, followed closely by the first Federal soldiers, who entered a city of ruination. *Library of Congress.*

Telegraph reported the story of a South Carolina officer who had just arrived in North Carolina. His eyewitness account of the carnage of February 18 was grim testimony to the fall of the "Cradle of Secession":

> *The evacuation took place on Friday night* [February 17], *and the city was occupied by about 500 Yankees who landed in small boats about 12 o'clock on Saturday. All the cotton (some 6,000 bales) and the shipping was destroyed, and the guns spiked by the military authorities. The city is now but little more than a heap of ruins. When the Yankees entered, nearly half of it* [Charleston] *was in ashes, and a terrible fire was still raging. The fire originated in two ways.*
>
> *A quantity of gunpowder had been left at the depot of the Northeastern Railroad Company, among a number of other articles. A crowd of negroes and citizens of the lower class had assembled for the purpose of pillage. While there, a boy in sport fired a small quantity of loose powder, which, communicating with that in the boxes, ignited the whole, causing a terrible explosion, with considerable loss of life. The immense depot building was blown to atoms, and the fire spread rapidly to the adjoining houses. It burned with great rapidity, and extended as far up on King Street as the Soldier's Home.*
>
> *About the same time a fire broke out in another portion of the city, caused by the burning of the Savannah Bridge* [over the Ashley River]. *This fire was also very destructive, and the two combined extended from river to river. Numerous other fires also occurred before the occupation of the city by the Yankees.*

After years of war, with the incessant Yankee bombardment now halted, it was an odd sight indeed to see the soldiers in blue pulling the fire engines and

Return for Fire. Chappel, Washington, Alexander Charlotte, Calhoun, East Bay, & Meeting Street February 18' 1865. commenced about 6 o'clock A.m. Discharged at 8 o'clock P.m

Eagle
Phoenix
Charleston 13 ??
Aetna
Marion
German
Palmetto
Hope
Washington
Steamer

City Engines

Engine No 1
 " " 2
 " " 4
 " " 5
 " " 6
 " " 7
 " " 8
 " " 9
 " " 10

Yankee landed and put a Guard at the Fire

The official ledger of the fire department shows the response to the explosion and fire at the depot in February 1865.

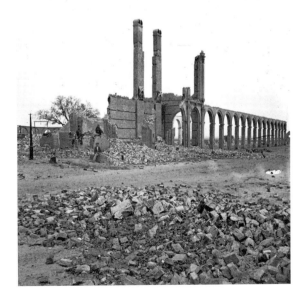

The skeleton of the train depot sits as a silent monument to the hundreds of men, women and children blown into eternity by an explosion of Confederate gunpowder. This tragedy came at a time when Charleston was already reeling from the evacuation of the city and the rumor of General Sherman's approach *Library of Congress.*

prodding the blacks into service, all to extinguish a fire in the very heart of the city that spawned the rebellion. The Confederacy had been the soul and salvation of the city. Created in the flames of disunion, the fires and explosions of February 1865 sounded the death knell of a cause now extinct. One year after the war, Charleston City Council enacted an ordinance that provided for the issuance of 7 percent bonds, intended to invigorate the rebuilding of the burnt district. Fraught with complicated details on repayment, the ordinance was eventually found unconstitutional by the South Carolina Supreme Court in 1885. From the end of Hassell Street to the end of Tradd Street, the city would remain bisected by the scar of the 1861 fire for the remainder of the century.

Charleston's volunteer fire companies served double duty as militiamen and provost guards. Fireman Charles R. Rogers wrote a letter dated June 7, 1864, which described his duties:

We firemen have had a devil of a time lately. One afternoon about three weeks ago the Alarm bell rung for fire, but instead of going to put out one we were marched to the Orphan house where we were addressed by the Major and requested to volunteer a visit to Jim [James] Island and assist in shooting the Yankees should they appear. Of Course the boys agreed unanimously. They were armed and equipped and ready in an hour…on Sunday following bang went the Old bell again and out we [went] as anxious and bloodthirsty as any rebel and this time eight companies went over.

[T]hey returned to town after a bloodless Campaign of two days. Since then and until last Saturday we have done guard duty for the Provost Marshall and Enrolling Officer…there was a fire downtown last week and the Yanks dropped their Shells in town like peas. One struck the Phoenix Engine, demolishing one of its pumps, part of the brakes and tore open the side of the box. A negro with whom Wm. Thomas had just changed places lost his arm…my engine (The Hope) was just along side and I tell you that shell came too near me to be agreeable. The boys stand them much better than I expected. Suppose all hands like myself think it much better than stopping Minie Balls.

RECONSTRUCTION AND THE STATUS QUO

D estined to rejoin the Union, South Carolina endured the purgatory that was Reconstruction, an era that also ended as southern blacks moved north by the trainload. Exposed to the "Southern Negro" for the first time, many northerners questioned whether the South could be reconstructed at all. Under the aegis of the federal government in Washington, blacks had enjoyed a brief but false sense of achievement. Many had held office during Reconstruction as senators, congressmen or judges. Black businessmen prospered, and black ministers preached the glory of redemption. But as northern sympathizers, also known as Republicans, began to quit the federal government's experiment in racial harmony, the gains that some blacks achieved were swept away by the presidential election of 1876.

The controversy erupted after New York governor Samuel J. Tilden appeared to have won the popular vote by more than 250,000 ballots. In question were the electoral votes of South Carolina, Florida and Louisiana, which were so convoluted that a "democratic" tally and a "republican" tally were forwarded to Washington for consideration. Only the behind-the-scenes work of an electoral commission could resolve the dilemma, with Rutherford B. Hayes winning out. The odd victory led to the Compromise of 1877, in which Hayes agreed to serve only one term and, more importantly, agreed to end Reconstruction in the South. For those promises, southern Democrats assured the government that they would not protest the result.

With former Confederate cavalry general Wade Hampton now governor of South Carolina, home rule returned, but so did the denigration of black people. Life for everyone in Charleston returned to a pace much like that before the war. Careless habits being hard to break, the 1870s saw four

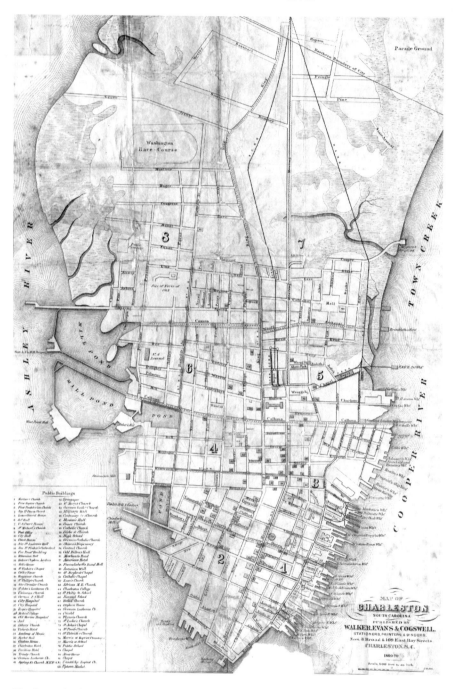

Charleston in the 1870s shows the expansion of the city limits well beyond the old boundary of the Neck. This area held a concentration of poor shanties and run-down buildings, easily susceptible to destruction by fire. *Special Collections, Charleston County Library.*

Former general and later governor of South Carolina Wade Hampton. It was during his tenure that the state's Reconstruction government was reverted to home rule. *Library of Congress.*

President Rutherford B. Hayes, whose election in 1876 as nineteenth president of the United States was such an enigma that it was settled only by the work of a specially appointed commission. *Library of Congress.*

major fires, the first of which began in the heart of the old city district that had been burned repeatedly in years past.

On December 15, 1874, the Champion Cotton Press at the corner of Church and Cumberland Streets caught fire. The *Charleston News and Courier* reported the progress of the flames:

> *The alarm instantly filled the streets with crowds of firemen and anxious spectators, but the intense heat and the fury of the flames, with which the whole building was in a very few moments enveloped, kept the throng from a near approach to the burning press. It is definitely known that the fire broke out in a bale of cotton…as soon as it was discovered that there was fire in the bale the young man who ascended on the elevator with the burning bale endeavored to whip the fire out with his hat…*
>
> *The district fire engines were on the spot and at work. At first, drawing water from distant wells, they could not accomplish much…they got information of the immense supply of water in the huge reservoir on the premises of the gas company, and as fast as they could they…were pouring upon the burning mass.*

The problem was not a shortage of men or equipment. In 1870, the department consisted of twenty-one volunteer companies numbering over 1,600 men. Eleven of those companies were steam engine companies. There were seven "colored" companies, which used the old hand engines. What the city lacked was a series of dependable water sources other than wells and tidal drains, which could run dry, leaving nothing to put on the fire.

The black companies carried names new to the ranks of the volunteer companies, but what these firemen lacked in training and experience they made up for in pride and enthusiasm. The Ashley, Niagara, Union Star, Comet, Prudence, Promptitude and United "colored" fire companies competed with one another much as the white companies did to be first on the scene. But with the return to the prewar status quo, these companies usually found themselves answering calls in predominantly black parts of Charleston, now referred to as "darktown" or "jungletown."

Little of Charleston's governmental resources were directed at a segment of the population thought to be lazy, unhealthy and prone to a life of crime. Pushed aside after having enjoyed some moderate social and political gains during Reconstruction, Charleston's black neighborhoods were like piles of firewood, waiting for a match. The "colored" fire brigades, poorly equipped and supervised, could do little but watch as countless shacks blazed against the night sky.

Two Centuries of Fire and Flames

With no hydrants for firemen to connect hoses to, the 1874 fire played out like any other fire one hundred years before. A year later, on July 23, 1875, the lack of water coupled with the escapades of the "colored" fire companies provoked protests intended to bring attention to the fire department's shortcomings. According to the *News and Courier* on July 24, 1875, the fire started on Gadsden Wharf:

> *The property lost consists of naval stores, residences and outbuildings, wharf property and small vessels...it began in the grocery of Mr. Henry O. Everhardt, at the corner of Marsh and Inspection streets, a few minutes before 2 a.m. on Saturday...the route of the fire was at first in a southerly direction, but it changed soon after it had consumed several buildings, and then spread north and north-east. The flames destroyed everything half-way between Marsh and Washington streets, crossed Marsh street to Concord, then crossed to Wharf street and finally to Cooper River...the management of the fire was the subject of much criticism...many expressing the opinion it was badly handled. On the other hand, the firemen say that the neighborhood was built of exceedingly combustible material.*

A witness to the fire wrote an extended letter to the editor, which was published alongside the report of the fire:

> *On Friday night last my sleep was interrupted by the angry peals of a fire bell, and the sonorous voice of a policeman bawling "fire" with commendable vigor...presently sufficient firemen were around to start the apparatus, and there came a confusion of voices—a low murmur at first, but increasing in intensity and discordance as it approached. That colored fire company hadn't quite the speed of Mark Twain's jackass rabbit, but it rushed along with something of a noise, keeping close upon the heels of a colored gentleman who made hideous noises through a battered horn. We hope he may have nothing to do with the field music on Judgment Day.*
>
> *As that company rushed by as though old Nick himself was at their heels...I started for the scene...for nearly three hours I sauntered about watching the steady advance of the flames and afterwards returned to my bed, not much wiser for what I saw, but quite sad for the homeless. From first to last I was impressed with the bane of a volunteer fire department, a relic adapted to this age about as much as a flintlock musket to the modern soldier...there should be reorganized all that pertains to the personnel and material of the fire department—bringing forth order from chaos. I am told the city possesses eleven steam fire engines and numerous other old wagons*

The camaraderie of the volunteer firefighter was shared by the "colored" fire companies as well. All volunteer companies boasted of balls, dinners and parades that gave the men a chance to show off their company's equipment and skills. *Douglas Bostick Collection.*

With Reconstruction on the wane, blacks once again became the brunt of racist humor. This cartoon illustrates the shenanigans of a "colored" fire company, though at times their actual acquittal at a fire scene was less than professional, owing mostly to the failure of white departments to provide them with training or equipment. *Library of Congress.*

with handles for the amusement of the colored population…by disposing of those old engines to neighboring villages…and the steamers remaining, with a wagon full of extinguishers manned, would fulfill all the requirements of this city…

Probably the existing department has a head, but during my stay at the fire, I saw no one who seemed to be in authority, each organization seeming to be its own master…at the time the companies reached the conflagration, probably no department, however organized could have stayed the flames, but who can say that acres of charcoal and lonely chimneys would now mark the scene had four or five engines, appliances and extinguishers in skilled hands been on the site in less time than was required to muster strength enough to get the engines fairly started.

That editorial would echo across Charleston for several years before any real change occurred in the fire department's organization. On March 30, 1876, a fire at the corner of King and Columbus Streets destroyed over one hundred homes, leaving men, women and children in the cold. Most of the displaced were poor and black. Many lived in what white folks called "shanties."

Chief Moses Henry Nathan retired in 1873. He was replaced by F.L. O'Neil, who held the post until 1894. By 1880, the Charleston Fire Department had fourteen steam engines. Now there were fire hydrants to draw from when the tidal drains were low, as they usually were. These new water mains were tied to the artisan water wells, which provided an ample draw of water. "Hook and Ladder" trucks were also in use, which greatly increased the opportunities for the firemen to rescue both lives and property.

The arduous task of hauling the steam engines to the fire gave way to pulling them by horses. This innovation was instituted in the late 1870s after so many complaints about the time it took for firemen to drag the multi-ton steamers to the fire. The unknown editorialist of July 1875 must have hailed this news with great satisfaction.

THE CHARLESTON FIRE DEPARTMENT IS FORMED

The mayor of Charleston from 1879 until 1887 was William A. Courtenay. The condition of the fire department was a major topic of discussion during the election, and Courtenay had vowed to look into the need for improvements. An ordinance was soon passed by Charleston City Council establishing a full-time, paid fire department. The traditions of the volunteer companies would be set aside once and for all as professional firemen manned the engines. Change had finally come, but many wondered at what cost. Charleston's memories of the losses of the past were long and troubled. The ruins of St. John's and St. Finbar's Cathedrals still stood as stark reminders of the insatiable nature of a fire out of control.

To make the transition as practical as possible for all parties, the ordinance allowed for the purchase of as much of the volunteers' equipment as the city could use. The existing firehouses were acquired and furnished with bedding and chairs. Along with a new coat of paint, swinging harnesses were improvised in each firehouse so that the horses could be coupled to their engines and the whole unit driven out of the doors in a minute. Fire hoses and reels were purchased and reworked to fit the other engines.

The single most important innovation was the use of a new fire alarm system. Though a previous system had been used, it fell into disrepair. This improved telegraph system manufactured by the Gamewell Fire Alarm Telegraph Company came with alarm bells weighing over one ton each. Whereas the old system had only twenty-six signal boxes, the new system had ninety-six, giving protection from the Battery to the growing part of the city beyond Line Street. The actual distance of wire strung to support the system increased from ten miles to thirty miles.

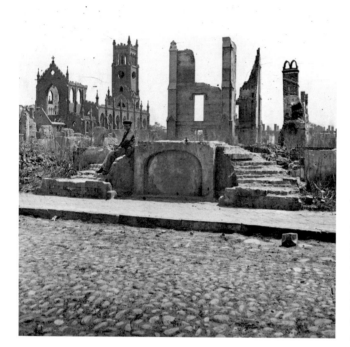

The ruins of the Catholic cathedral at the corner of Broad and Legare Streets stood for years as a solemn reminder of how fragile Charleston's churches and other historic structures were. These concerns helped promote a change in the organization of the fire department. *Library of Congress*

In its final form, the new Charleston Fire Department consisted of 103 officers and men, eight steam engines, ten hose carriages and reels, two hook and ladder trucks, six thousand feet of hose and two fuel wagons. In the board of fire masters' annual report from 1882, Chairman Francis F. Rodgers gave a stellar review of the progress made in establishing the Charleston Fire Department:

> *The first year of the new department has passed, and with results so entirely satisfactory as to vindicate the change made and warrant the additional outlays to secure it. The execution of the ordinance was placed in the hands of public spirited citizens, who gave their best thought and ample time to their work, and in an incredibably [incredibly] short period they had the new department in good working order, and at the close of the year Charleston was under the protection of as efficient a fire service as the most favored city in the Union...the officers and men of the department exhibit as much pride in the perfection and esprit of their organization as the volunteer firemen of the past, and we all know that in their day and generation they were unexcelled anywhere.*

EPILOGUE

In 2009, the Charleston Fire Department is by every definition of the word a "modern" firefighting agency, but like its earliest predecessors—the volunteer fire companies—it would also take years for tradition to yield to progress. The old main station on the south side of Queen Street between King and Meeting was replaced in 1888 by a brick station at Meeting and Wentworth, which stands today as humble tribute to the men who would over the years give their lives in the line of duty.

Inside this station, the old meets the new. The modern fire engines gleam in the sunlight, silent sentinels ready to spring into action with the tolling of the alarm bells. In another bay, a genuine steam fire engine sits next to other fire trucks from an era long gone, while a hand hose reel sits in the corner. Each fireman (and, yes, today there are women in the ranks, too) wears a patch on his uniform shirt sleeve displaying the Maltese cross embroidered over an old steamer together with the words "Charleston Fire Department."

One tradition remains today that no amount of time or change can erode. When the alarm sounds and the firemen respond, each one knows that he may not make it back to the station alive. But go they do, into the thick of the smoke and the heat of the flames, into places where mere mortals dare not tread. That's because firemen are our guardian angels who protect us and our families from harm. Their angelic faces are lost under the mask and helmet. You may not see their wings because of the oxygen tanks strapped to their backs, but fly they do—into a house, a store or a factory. Some rise high above the flames and point streams of water into the hot spots. Others flit from one passenger to another in a smoking fuselage, daring the jet fuel to ignite. Somewhere on a dark country road, heavy gloves cover the hands

made in heaven as they lift a bloodied child from an overturned car and place him into an ambulance.

Take time and stop by the main station and enjoy the history. Take your kids and let them see the old engines of the past. Shake a fireman's hand and remember—that hand is a helping hand. You may never need it, but it's always there, waiting for the alarm to sound!

BIBLIOGRAPHY

Abbott, Martin, and Elmer L. Puryear, eds. "Beleaguered Charleston: Letters from the City, 1860–1864." *South Carolina Historical Society Magazine* 61 (1960).

Bacot Family Collection, 1752–73. Collection of the South Carolina Historical Society.

"The Battle of Fort Sumter and First Victory of the Southern Troops, April 13." Charleston, SC: Evans and Cogswell, 1861. Collection of the South Carolina Historical Society.

Bellows, Barbara. *Benevolence Among Slaveholders: Assisting the Poor in Charleston, 1670–1860.* Baton Rouge: Louisiana State University Press, 1993.

Calderone, John A. "Fire Apparatus: Past and Present." *Firehouse* (September 1998).

Charleston City Gazette.

Charleston Mercury.

Charleston News and Courier.

Charleston Times.

City of Charleston Board of Fire Masters. Minute Book. Special Collections, Charleston County Library.

City of Charleston Yearbook, 1852 and 1880. Collection of the South Carolina Historical Society.

Clary, James B. *Evacuation of Confederate Forces from Charleston in 1865: A History of the Fifteenth South Carolina Volunteer Infantry, 1861–1865.* Spotsylvania, VA: Sergeant Kirkland Museum and Historical Society, 1997.

Constitution of the Marion Fire Engine Company of Charleston. Charleston, SC: Denny & Perry, Printers and Stationers, 1869. Collection of the South Carolina Historical Society.

BIBLIOGRAPHY

Crooks, Daniel J., Jr. *Lee in the Lowcountry: The Defense of Charleston and Savannah.* Charleston, SC: The History Press, 2008.

Cybularz, Rebecca M. "Where's the Fire? A History of 27 Anson Street, Charleston, South Carolina." Unpublished paper, College of Charleston with Clemson University, November 20, 2008.

Daniel Cannon Webb Plantation Journals, 1817–1850. Collection of the South Carolina Historical Society.

Digest of the Ordinances of the City Council of Charleston. Special Collections, Charleston County Library.

"An Early Fire Insurance Company." *South Carolina Historical and Genealogical Magazine* 8 (1907).

Extracts from the 1861 Schirmer diary. *South Carolina Historical Society Magazine* 62 (1961).

Fayetteville Telegraph.

Ferguson, William. *America by River and Rail: Notes by the Way on the New World and Its People.* London: James Nisbet and Co., 1856.

Ferrara, Marie. "Moses Nathan and the Great Charleston Fire of 1861." *South Carolina Historical Society Magazine* 104 (2003).

Fraser, Walter J., Jr. *Charleston, Charleston! The History of a Southern City.* Columbia: University of South Carolina Press, 1989.

———. *Patriots, Pistols and Petticoats: Poor Sinful Charles Town during the American Revolution.* Columbia: University of South Carolina Press, 1993.

Gibson, Gail. "Costume and Fashion in Charleston, 1769–1782." *South Carolina Historical Society Magazine* 82 (1981).

Gray, Kathleen, comp. Records of the Special Committee on the City Fire Loan, 1867–1893. Charleston Archive, Charleston County Library.

Howe, Reverend William Bell White. *Cast Down but Not Forsaken: A Sermon Delivered in St. Phillips Church, Charleston, December 15th 1861.* Charleston, SC: Evans and Cogswell, 1861.

Insurance Company of North America. *American Fire Marks.* Philadelphia, PA: Insurance Company of North America, 1933.

Leland, Jack. "Holy City has Burned, Burned, Burned." *Charleston Evening Post*, February 4, 1979.

Letter from A. Fowler. Collection of the South Carolina Historical Society.

Letter to Dr. Francis L. Frost from John H.B. Jenkins, June 4, 1887. Collection of the South Carolina Historical Society.

Letter to Samuel and William Vernon from Nathaniel Russell, January 11, 1771. Collection of the South Carolina Historical Society.

Mulcahy, Matthew. "The 'Great Fire' of 1740 and the Politics of Disaster Relief in Colonial Charleston." *South Carolina Historical Society Magazine* 99 (1998).

Payroll of City Fire Engines, 1855–1869. Special Collections, Charleston County Library.

Pease, Jane A., and William H. Pease. "The Blood-Thirsty Tiger: Charleston and the Psychology of Fire." *South Carolina Historical Society Magazine* (1978).

Phoenix Fire Engine Company Records. Collection of the South Carolina Historical Society.

"The Pioneer Steam Fire-Engine." *Hutchings's California Magazine* (October 1856).

Radford, John Price. "Culture, Economy and Urban Structure in Charleston." PhD diss., Clark University, 1964.

"Report of the Chief of the Fire Department of the City of Charleston, S.C. ending May 21st, 1866." Charleston, SC: Joseph Walker, 1866.

"Report of the Chief of the Fire Department of the City of Charleston, S.C., ending 1868." Charleston, SC: Walker, Evans and Cogswell, 1868.

"Report of the Chief of the Fire Department of the City of Charleston, S.C., ending 1869." Charleston, SC: Walker, Evans and Cogswell, 1869.

Rhett, R. Goodwyn. *Charleston: An Epic of Carolina.* Richmond, VA: Garrett & Massie, 1940.

Rogers, George C. *Charleston in the Age of the Pinckneys.* Tulsa: University of Oklahoma Press, 1969.

Rosen, Robert. *A Short History of Charleston.* Columbia: University of South Carolina Press, 1992.

Sams, Betsy. "The Great Fire of 1740." *Charleston News and Courier*, November 13, 1960.

Schirmer family journals and registers, 1806–1929. Collection of the South Carolina Historical Society.

Scott, Kenneth. "Sufferers in the Charleston Fire of 1740." *South Carolina Historical Society Magazine* 64 (1963).

Sellers, Leila. *Charleston Business on the Eve of the American Revolution.* Chapel Hill: University of North Carolina Press, 1934.

Smyth, Reverend Thomas. "Two Discourses on the Occasion of the Great Fire in Charleston." Charleston, SC: John P. Beile, bookseller, n.d. Collection of the South Carolina Historical Society.

South Carolina and American General Gazette, number 993, January 29, 1778.

South Carolina Gazette, number 352, November 13–20, 1740.

South Carolina State Fireman's Association. "21st Annual Convention and Golden Jubilee of Chief Behrens." Charleston, SC: Southern Printing and Publishing Company, 1926.

South Carolina State Firemen's Association. "21st Annual Convention of the South Carolina State Firemen's Association." Charleston, SC:

Southern Publishing and Printing Company, 1926. Collection of the South Carolina Historical Society.

Stevens, Michael E. "The Vigilant Fire Company of Charleston." *South Carolina Historical Society Magazine* 8 (1986).

Stoney, Samuel G., ed. "The Great Fire of 1778 Seen Through Contemporary Letters." *South Carolina Historical Society Magazine* 64 (1963).

Trowbridge, John T. *A Picture of the Desolated States and the Work of Reconstruction.* Hartford, CN: L. Stebbins, 1868.

"Volunteer Firemen React to Steam Engines." *New York Herald*, September 4, 1858.

Wade, Richard C. *Slavery in the Cities: The South, 1820–1860.* New York: Oxford University Press, 1964.